99 Ways to Tell a Story: Exercises in Style

Matt Madden

Jonathan Cape
London

Centre for Business, Arts &Technology
444 Camden Road
London N7 0SP
020 7700 8762
batlib@candi.ac.uk

CITY AND ISLINGTON
COLLEGE

This book is due for return on or before the date stamped below. You may renew by telephone. Please quote the barcode number or your student number. This item may not be renewed if required by another user.

Fine : 10p per day

1 WEEK LOAN

0 7 MAY 2020

Also by Matt Madden

BLACK CANDY
(Black Eye Books)

ODDS OFF
(Highwater Books)

?!:,.

ɔefɡ
h i k
l m n
o r s
t w y

I T W

Published by Jonathan Cape 2006

First published in the United States in 2005 by Chamberlain Bros., the Penguin Group

10

Copyright © Matt Madden 2006

Matt Madden has asserted his right under the Copyright, Designs
and Patents Act 1988 to be identified as the author of this work

First published in Great Britain in 2006 by
Jonathan Cape
Random House, 20 Vauxhall Bridge Road,
London SW1V 2SA

Random House Australia (Pty) Limited
20 Alfred Street, Milsons Point, Sydney,
New South Wales 2061, Australia

Random House New Zealand Limited
18 Poland Road, Glenfield,
Auckland 10, New Zealand

Random House (Pty) Limited
Isle of Houghton, Corner of Boundary Road & Carse O'Gowrie,
Houghton 2198, South Africa

The Random House Group Limited Reg. No. 954009

www.randomhouse.co.uk

A CIP catalogue record for this book is available from the British Library

ISBN 9780224079259 (from January 2007)
ISBN 0224079255

Papers used by Random House are natural,
recyclable products made from wood grown in sustainable forests.
The manufacturing processes conform to the environmental
regulations of the country of origin

Book design by Charles Orr

Printed and bound in India by Replika Press Pvt. Ltd.

The author would like to acknowledge his debt to Raymond Queneau, whose influence extends well beyond the inspiration for this book.

Contents

Introduction

Each comic in this book presents the same story—recounts exactly the same events—but takes a different approach to telling the tale. You will find varying points of view, different styles of drawing, homages and parodies, as well as interpretations that may challenge your idea of what exactly narrative is. For example, can a map tell a story? How about a page full of advertisements? I'm not suggesting that there's a definite answer, only that it's exciting to consider how many ways a story can be told, how art and text interact, and how these comics relate to other visual and narrative media.

This book was inspired by Raymond Queneau's *Exercises in Style* in which he spun ninety-nine variations out of a basic, two-part text relating two chance encounters with a mildly irritating character during the course of a day. He started by telling it in every conceivable tense, then by doing it in free verse, and then as a sonnet, as a telegram, in pig latin, as a series of exclamations, in an indifferent voice . . . you name it, he did it.

From the first time I read *Exercises in Style*, I thought it would be fun and challenging to apply the idea to a visual narrative, but dismissed it as a crazy notion. However, years went by and still the concept kept coming back to nudge me toward the drawing table. Six years ago, I finally gave in and put pen to paper. The reaction among my peers, friends, and family to the first few exercises was instantaneous and enthusiastic: I knew I had no choice but to see this through to the end.

Although there is a certain sequence to these pages, it is perfectly allowable to read the exercises in random order. Nor is there any requirement to read every comic in one sitting (or ever). Your first dive into these pages will make you want to come back from time to time in order to browse through the book, look up a favorite comic, or show it to a friend, much as you would with a collection of poetry or drawings.

Can a story, however simple or mundane, be separated from the manner in which it is told? Is there an essential nugget from which all stylistic and physical characteristics can be stripped? What would that core look like? This book begins with a comic I named "Template" because it has the least overt manipulation of formal elements. Yet even a moment's consideration yields a series of questions: Why is it drawn in pen and not with a brush? Why is it told in eight panels and how were they chosen? The style is not "cartoony," yet it is not quite "realistic"—Why? Suddenly it's clear that what appear to be merely "stylistic" choices are in fact an essential part of the story. In reading these comics you have the opportunity to question the effects that ways of telling have on what is being told, and, just as important, to enjoy the rich variety of approaches available to the artist, in comics and in other media.

Rather than rehashing the eternal battle between form and content, style and substance, I hope this work questions those tired dichotomies and suggests a different model: form *as* content, and substance inseparable from style.

—Matt Madden

Template

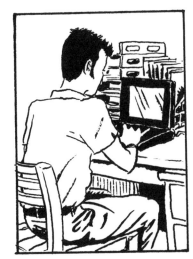
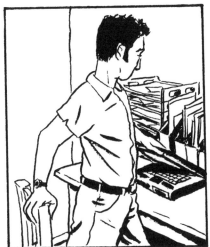
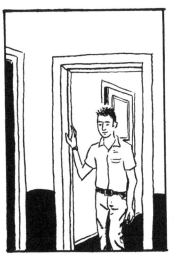
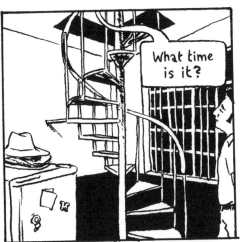
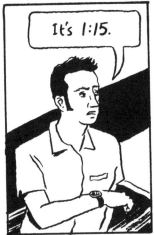
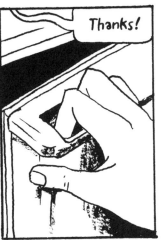

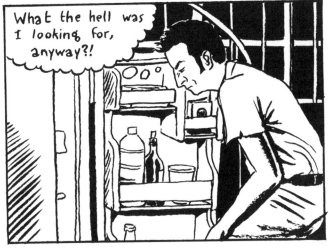

Monologue

I was working at the computer...

and I got up to get something out of the fridge.

I went into the dining room.

From up in the studio, Jessica asked me what time it was.

I told her it was around one...

I heard her say thanks from upstairs.

I guess I got distracted because when I opened the refrigerator door ...

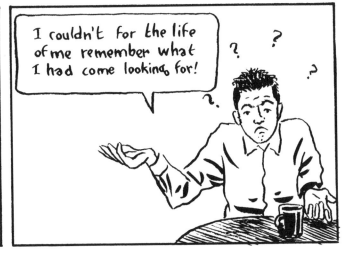

I couldn't for the life of me remember what I had come looking for!

Subjective

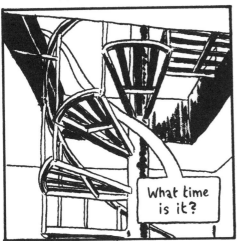
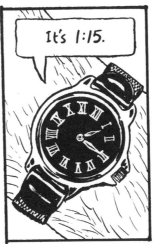

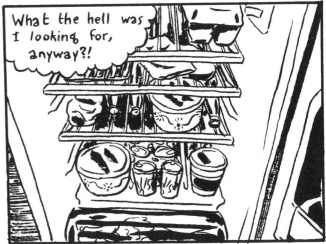

Upstairs

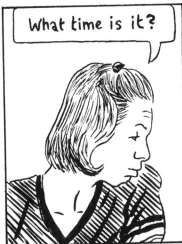

What time is it?

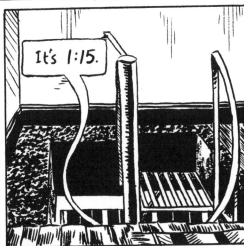

It's 1:15.

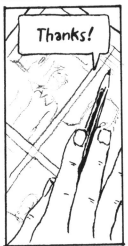

Thanks!

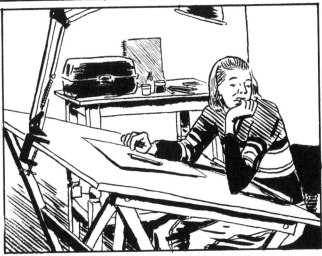

A Refrigerator with a View

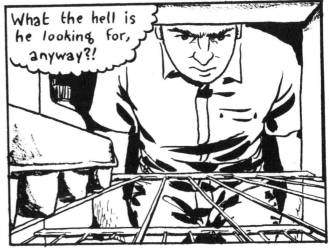

Voyeur

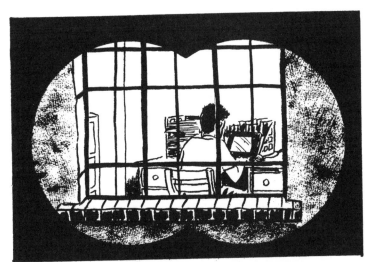

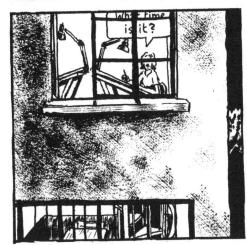

Sound Effects

Emanata

Inventory

How-To

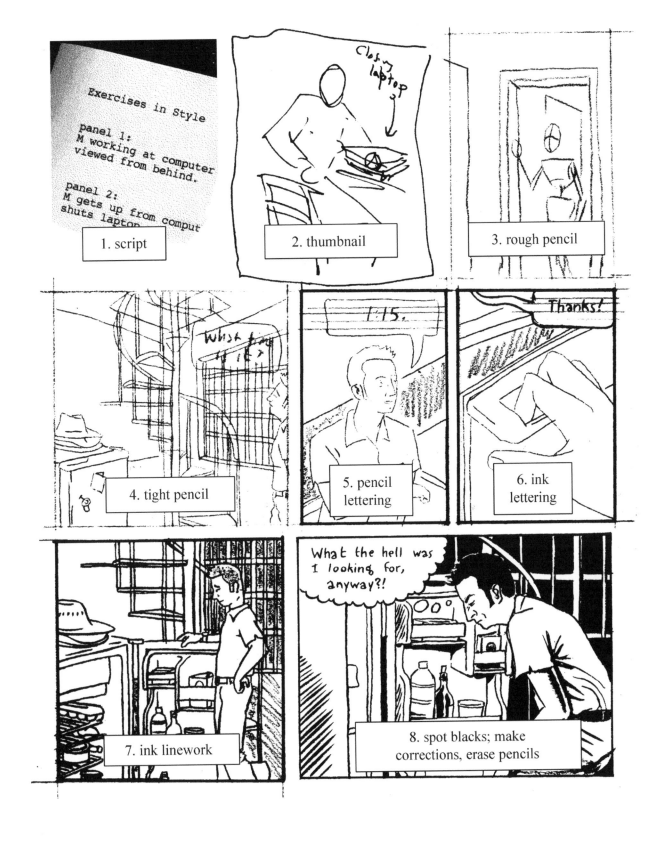

Welcome to
"Exercises in Style"

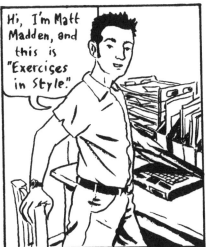

Hi, I'm Matt Madden, and this is "Exercises in Style."

I've taken a short, every-day incident and I'm trying to dream up as many variations on it as I can...

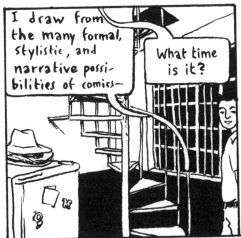

I draw from the many formal, stylistic, and narrative possibilities of comics—

What time is it?

It's 1:15.

Thanks!

—in order to suggest the almost limitless potential of the medium.

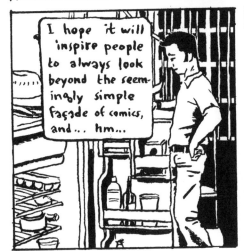

I hope it will inspire people to always look beyond the seemingly simple façade of comics, and... hm...

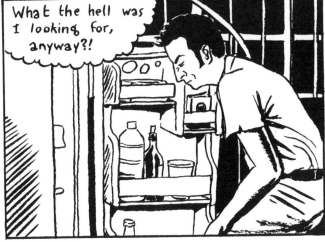

What the hell was I looking for, anyway?!

Retrograde

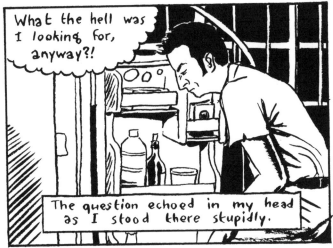

What the hell was I looking for, anyway?!

The question echoed in my head as I stood there stupidly.

I'd been standing there trying to remember for a few long seconds.

Thanks!

I suppose Jessica's thanks must have bumped whatever it was out of my head for good.

I had just told Jessica the time.

It's 1:15.

What time is it?

She was upstairs with no clock — she lost her watch again recently.

I had just left the office.

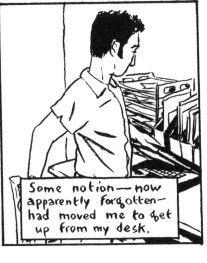

Some notion — now apparently forgotten — had moved me to get up from my desk.

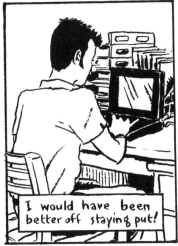

I would have been better off staying put!

Tense

Some vague need had spurred him to get up from his computer.

He went into the dining room, obscurely confident he would remember his goal when he saw it.

He was grabbing the refrigerator door, breaking the mild resistance of the vacuum seal.

He has opened the refrigerator door.

He forms a mental image of what he last saw in there.

He is noticing the familiar ice cube decal.

He will see that the butter and eggs are in the same place as always.

He will be scanning the contents of the refrigerator,..

He will not have remembered what the hell he was looking for.

Flashback

It all started with a simple question...

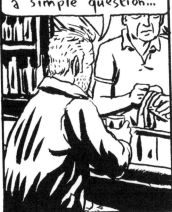

"It was in our apartment in Mexico City, back in '98.

"I had gotten up from my desk to get... something. Something.

"And then Jessica, who was upstairs drawing, she asks me:

What time is it?

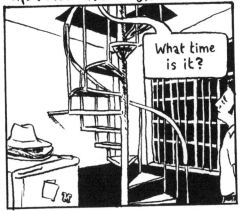

It's 1:15.

"Around that time I could tell something wasn't quite right.

Thanks!

"And I just stood there at that refrigerator and it's like I could see my life unravelling in front of me..."

And to this day I still don't know what the hell I was looking for...

EXIT

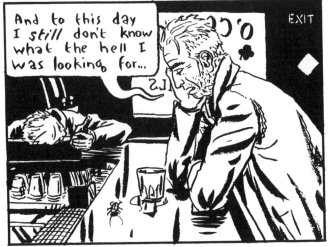

Déjà Vu

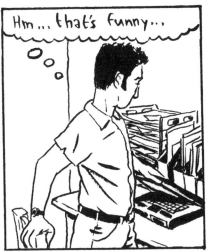

Hm... that's funny...

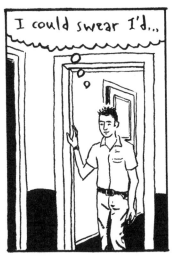

I could swear I'd...

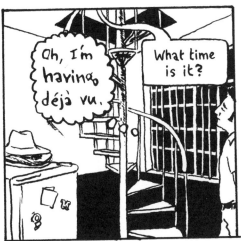

Oh, I'm having déjà vu.

What time is it?

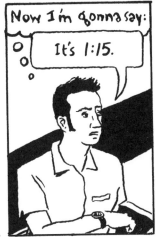

Now I'm gonna say:

It's 1:15.

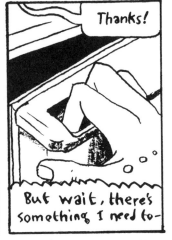

Thanks!

But wait, there's something I need to—

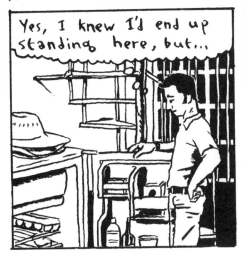

Yes, I knew I'd end up standing here, but...

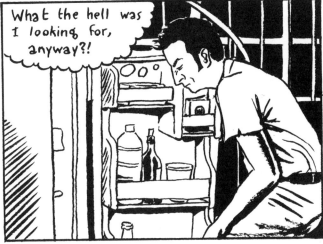

What the hell was I looking for, anyway?!

Unreliable Narrator

I remember that evening vividly—and, contrary to what you may have read elsewhere...

I was in complete control of my will and desires!

I strode purposefully into the dining room.

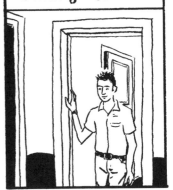

Insidious forces conspired to keep me from my fortunes...

What time is it?

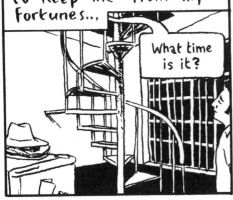

I offered them only disdain.

It's 1:15.

I paid no heed to their feeble bids to distract me.

Thanks!

And when I reached my goal I stood for a moment, soaking in my glory:

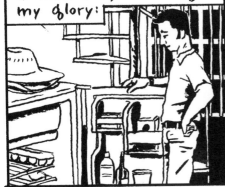

I knew exactly what I was looking for!

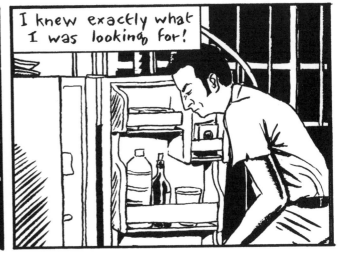

Dailies

MacHinery, P.I.

By Clint Smith

Life with Biggsie

By Brube

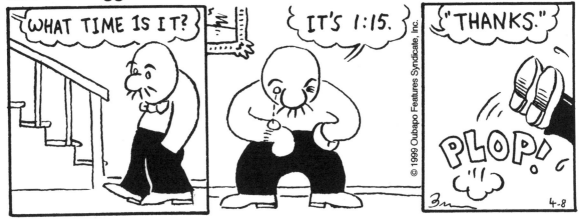

Poopsie the Cat

By MUGS

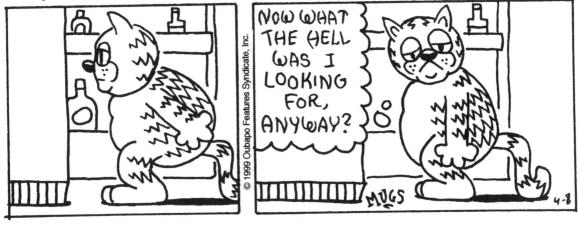

Political Cartoon

Photocomic

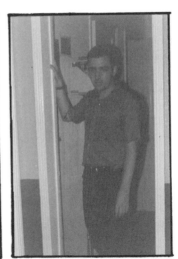
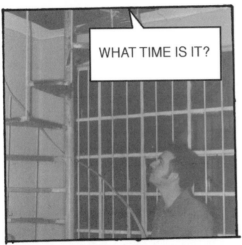
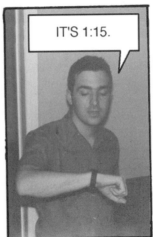
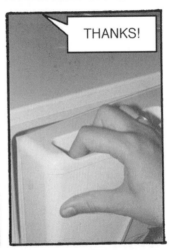
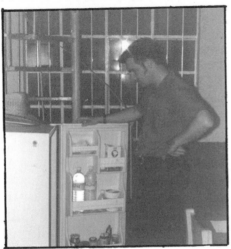
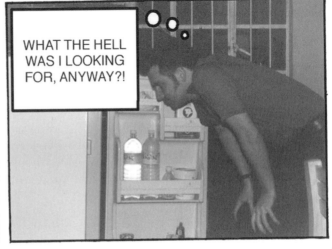

Underground Comix

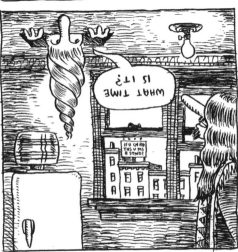

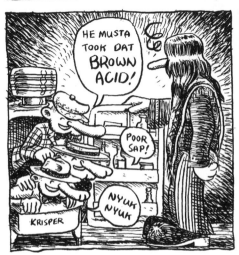

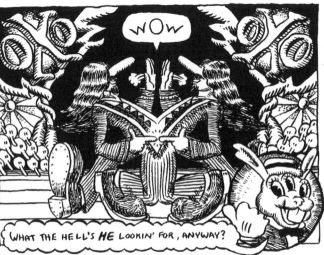

Manga

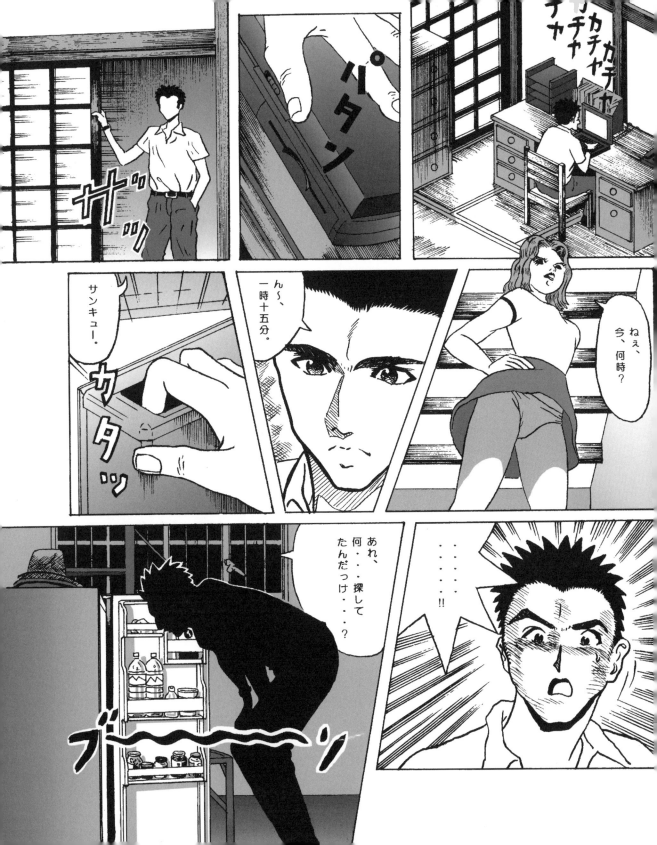

War Exercise

NORTHERN FRONT, 0109 HOURS. I'M HEADING BEHIND ENEMY LINES ON A CLANDESTINE SEARCH AND DESTROY MISSION.

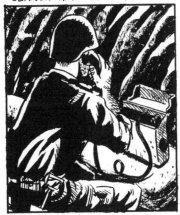

OUR CIVILIAN MOLE IS WAITING ON THE SECOND FLOOR OF THE LAST HOUSE ON "INFERNO ALLEY."

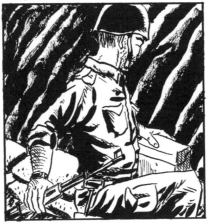

ONCE I GET HIS COUNTER-SIGN, I'M SUPPOSED TO OPEN FIRE--ON WHAT OR WHOM I DO NOT KNOW.

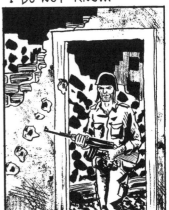

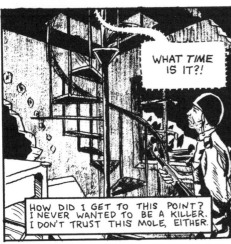

WHAT *TIME* IS IT?!

HOW DID I GET TO THIS POINT? I NEVER WANTED TO BE A KILLER. I DON'T TRUST THIS MOLE, EITHER.

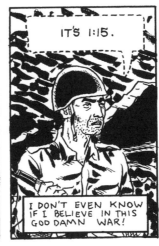

IT'S 1:15.

I DON'T EVEN KNOW IF I BELIEVE IN THIS GOD DAMN WAR!

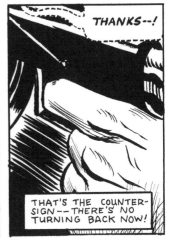

THANKS--!

THAT'S THE COUNTER-SIGN--THERE'S NO TURNING BACK NOW!

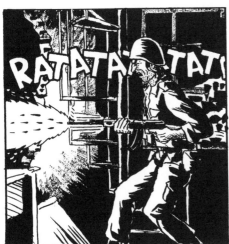

RATATA TAT

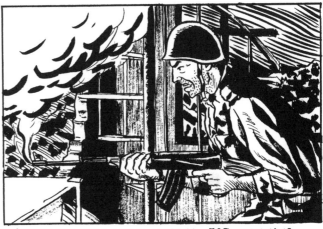

WHAT THE HELL WAS I LOOKING FOR, ANYWAY?

Exercises in Love

"YESTERDAY I ACCEPTED AN OFFER OF MARRIAGE FROM **BRADLEY BENTON**, BRANCH MANAGER FOR THE ENTIRE EASTERN DIVISION!

"I WAS THROUGH WITH THOSE WILD TYPES I USED TO DATE -- AND THE DAMAGE THEY DID TO MY REPUTATION...

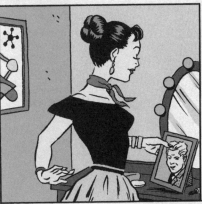

"TONIGHT I WAS GOING TO MEET BRADLEY'S PARENTS -- MY FUTURE IN-LAWS!

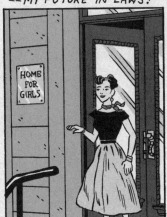

"THEN SUDDENLY A HUSKY, MASCULINE VOICE PENETRATED MY INNOCENT BLISS...

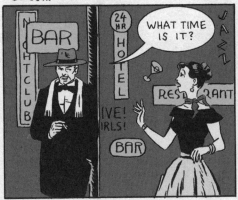

WHAT TIME IS IT?

"I COULD FEEL MY HEART BEGINNING TO BEAT IN EXCITED, CONFUSED PALPITATIONS...

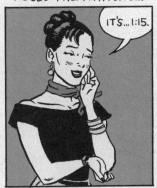

IT'S... 1:15.

"NO! I PROMISED MYSELF TO BRADLEY BENTON!

THANKS, DOLL!

"AND YET THE STRANGER'S THANKS PIERCED ME LIKE ARROWS LACED WITH SOME STRANGE ELIXIR!

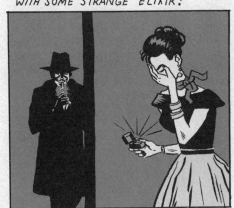

OH, BRADLEY, I'M SORRY!

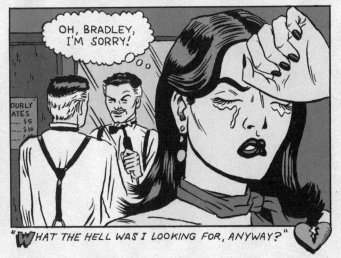

"WHAT THE HELL WAS I LOOKING FOR, ANYWAY?"

Fantasy

Plan 99 from Outer Space

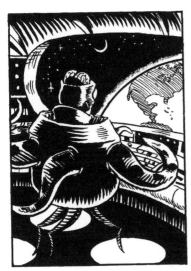
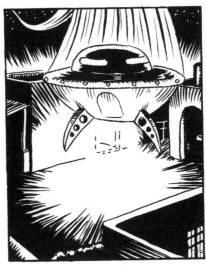
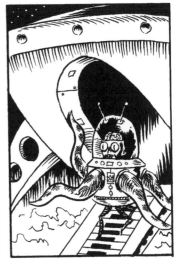
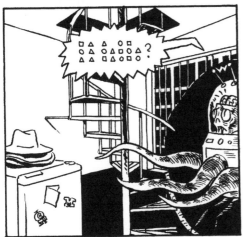
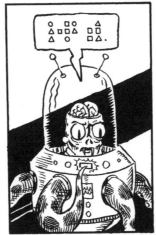

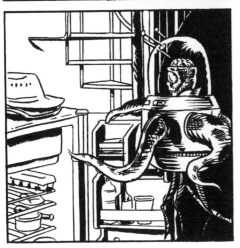
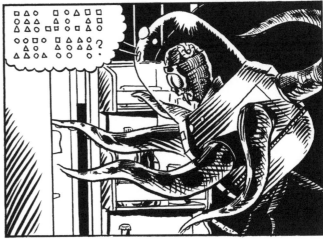

High Noon

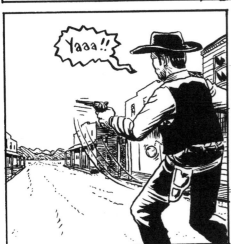

Police Procedural

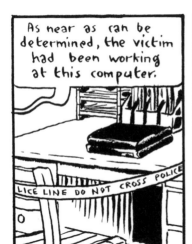

As near as can be determined, the victim had been working at this computer.

LICE LINE DO NOT CROSS POLICE

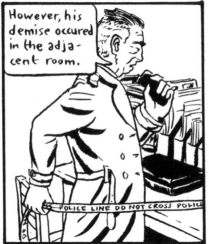

However, his demise occured in the adjacent room.

POLICE LINE DO NOT CROSS POLICE

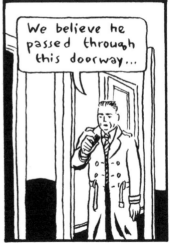

We believe he passed through this doorway...

An unidentified perpetrator then entered the premises, presumably via the upstairs door, and assailed the victim at, uh, what time, Randy?

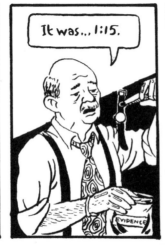

It was... 1:15.

EVIDENCE

Thanks.

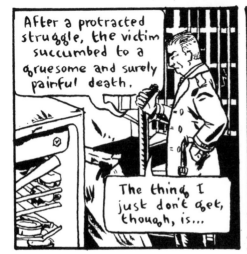

After a protracted struggle, the victim succumbed to a gruesome and surely painful death.

The thing I just don't get, though, is...

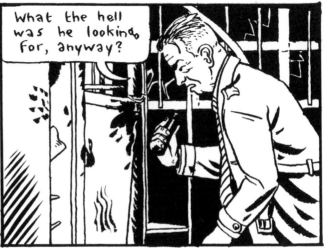

What the hell was he looking for, anyway?

Humor Comic

BABY NOO IN: "Snack Time?"

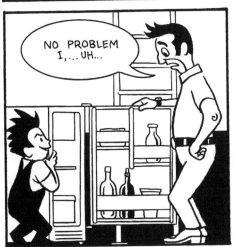

Furry

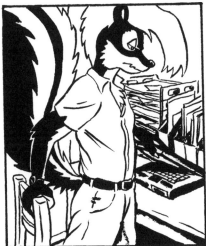

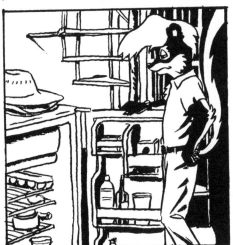
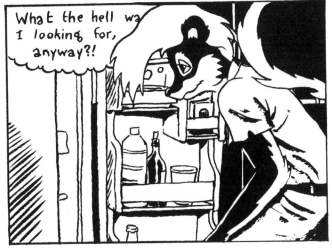

One Panel

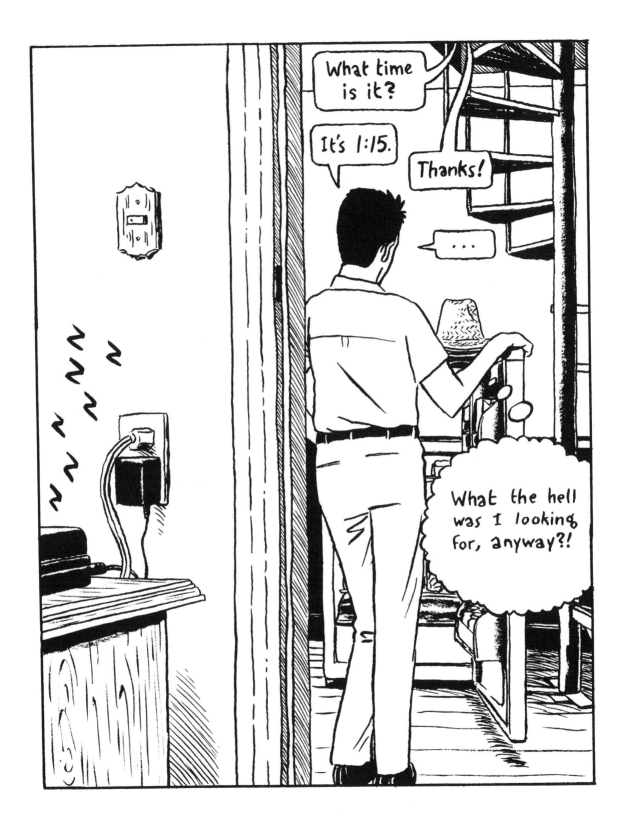

Thirty Panels

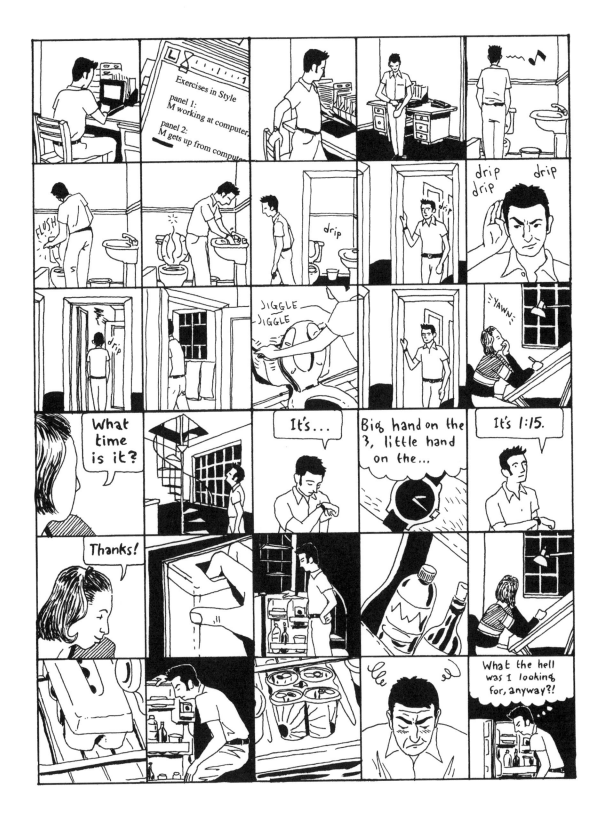

Plus One

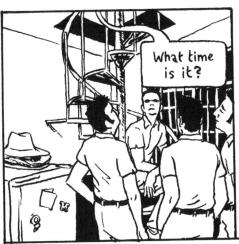
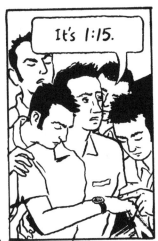
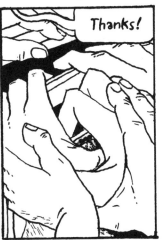
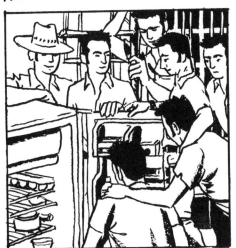
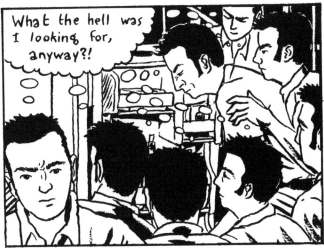

Etcetera

When I got up...

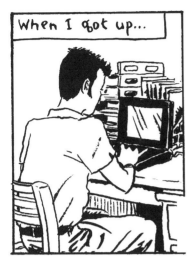

...I know I had something specific in mind...

And I must have still known it...

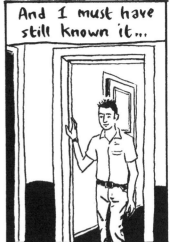

What time is it?

...when Jessica asked me the time.

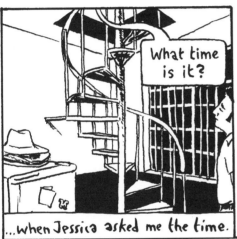

It's 1:15.

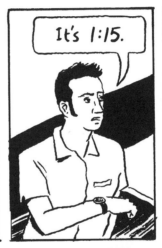

Thanks!

But:

What the hell was I looking for, anyway?!

OK OK, let's start from the beginning.

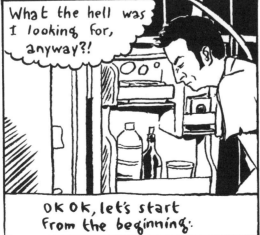

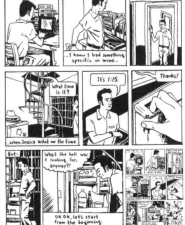

Opposites

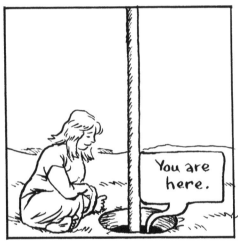
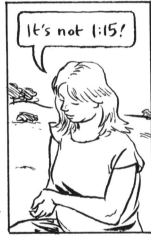

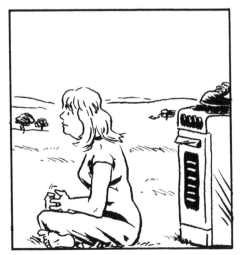
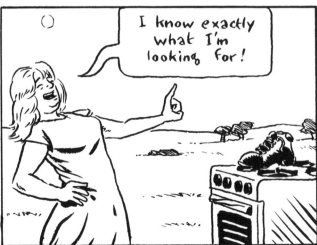

Reframing
(Hands and Punctuation Marks)

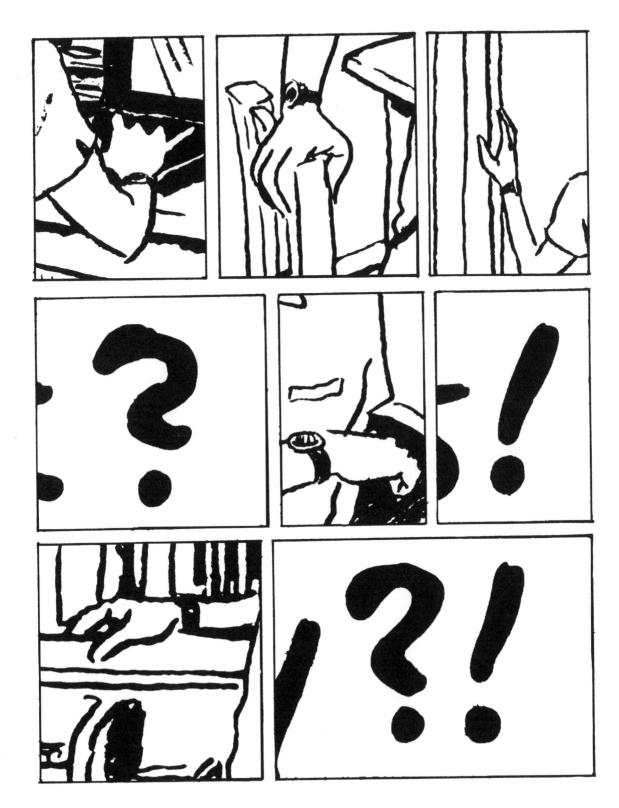

Inking Outside the Box

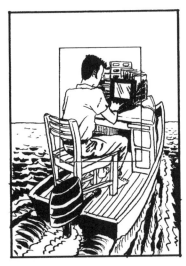

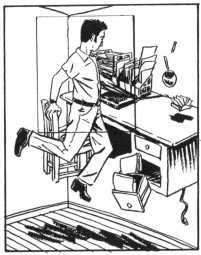

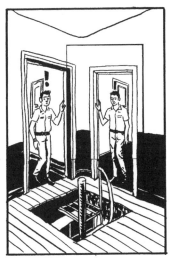

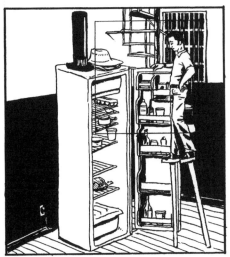

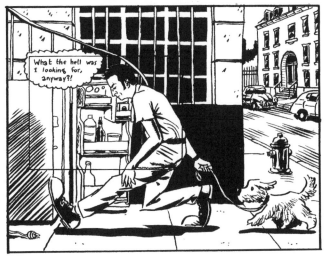

Palindrome

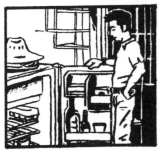
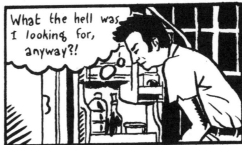
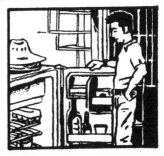

Anagram I:
In Exercises, Style

Thanks!

For the what? Hell, I was looking, anyway.

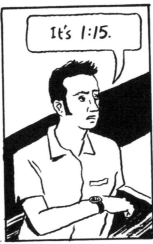

It's 1:15.

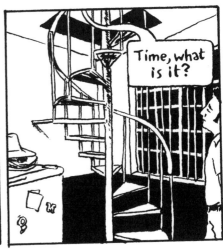

Time, what is it?

Anagram II:
Le Teeny Sex Crisis

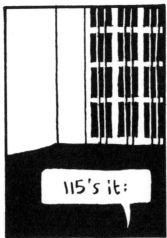

115's it:

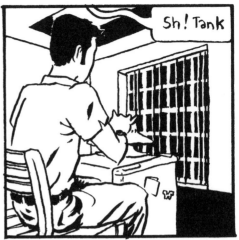

Sh! Tank

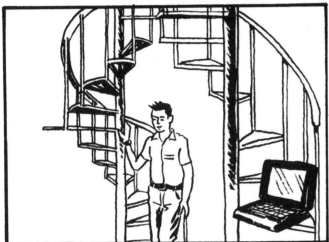

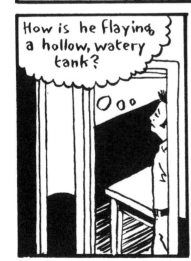

How is he flaying a hollow, watery tank?

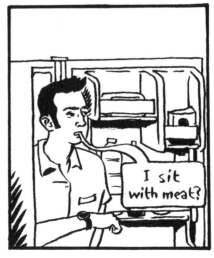

I sit with meat?

After Rodolphe Töppfer
(English Bootleg Version)

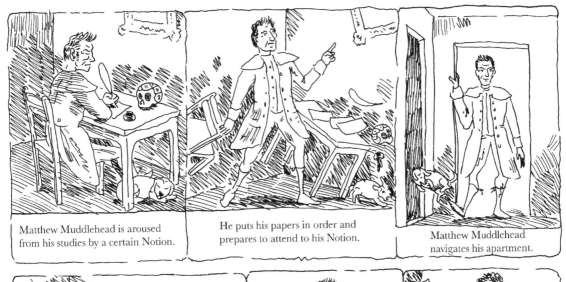

Matthew Muddlehead is aroused from his studies by a certain Notion.

He puts his papers in order and prepares to attend to his Notion.

Matthew Muddlehead navigates his apartment.

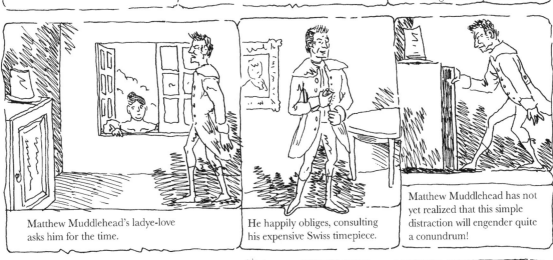

Matthew Muddlehead's ladye-love asks him for the time.

He happily obliges, consulting his expensive Swiss timepiece.

Matthew Muddlehead has not yet realized that this simple distraction will engender quite a conundrum!

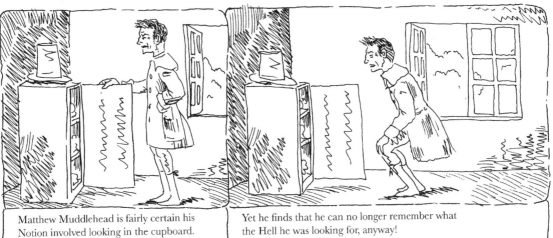

Matthew Muddlehead is fairly certain his Notion involved looking in the cupboard.

Yet he finds that he can no longer remember what the Hell he was looking for, anyway!

A Newly Discovered Fragment
of the Bayeux Tapestry

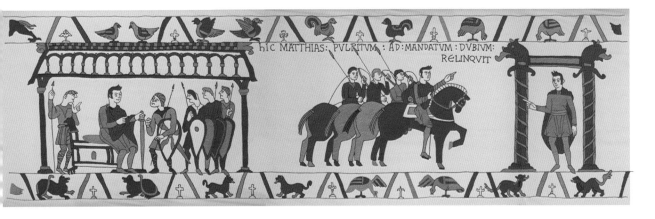

HIC MATTHIAS: PVLCRITVM : AD : MANDATVM : DVBIVM: RELINQVIT

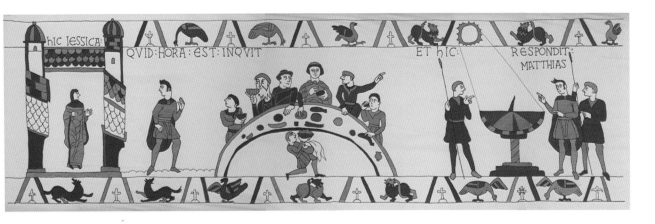

HIC IESSICA: QVID : HORA : EST : INQVIT ET HIC: RESPONDIT: MATTHIAS

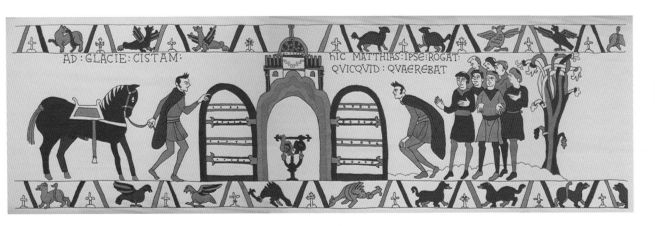

AD : GLACIE : CISTAM: HIC MATTHIAS : IPSE : ROGAT: QVICQVID : QVAEREBAT

What Happens When the Ice
Truck Comes to Hogan's Alley
(after Richard F. Outcault)

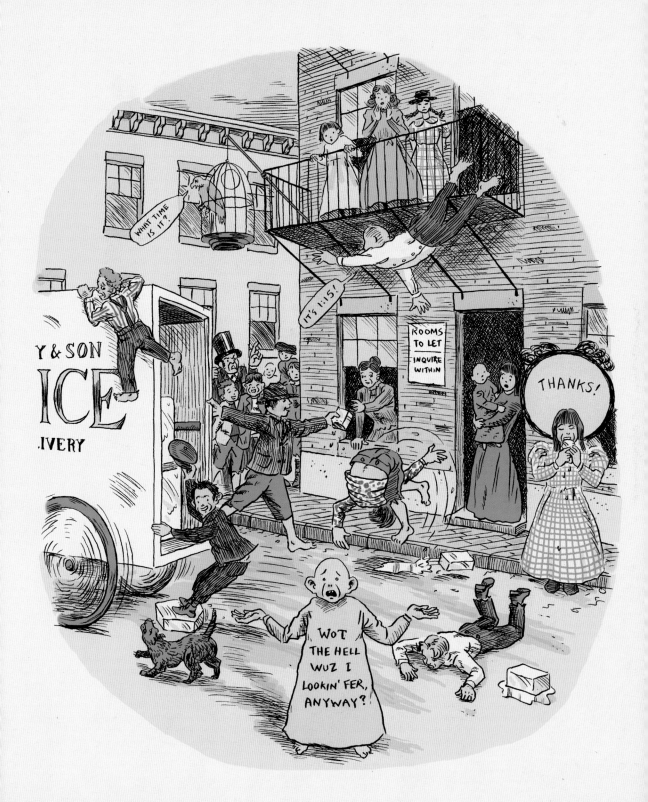

Exorcise in Style

HAW HAW HELLO THERE KIDDIES, IT'S THE *STYLE KEEPER* AGAIN, WITH A LITTLE TALE TO *TERRORIZE* YOU *TOTALLY* AND *FRIGHTEN* YOU *FORMALLY!!!* I LIKE TO CALL THIS ONE:

EXORCISE in STYLE!

YOUNG MATT MADDEN WAS CHANNELING HIS *OUIJA BOARD* ONE DARK NIGHT WHEN HE WAS SUDDENLY OVERCOME BY A *DREAD FOREBODING!!* HE FELT AN IRRESISTIBLE URGE PULLING HIM AWAY FROM HIS DESK...

AN *UNKNOWN FORCE* WAS DRAWING HIM... *INEXORABLY...*

...TO THE REFRIGERATOR!!

AS HE PASSED THE WINDING OLD STAIRCASE HE HAD NEVER DARED TO CLIMB, A *HORRIFYING VOICE* CALLED OUT TO HIM...

WHAT TIME IS IT?

CRAZED WITH FEAR, YOUNG MATT COULDN'T HELP BUT DO THE *SHE-DEMON'S* AWFUL BIDDING!!

I-IT'S *1:15!*

AS THE *BANSHEE'S* VOICE RECEDED INTO THE *BOWELS* OF THE *BUILDING,* MATT SLOWLY OPENED THE REFRIGERATOR DOOR!!

THANKS! EH... EH... EH...EH...

THE OLD DOOR CREAKED MALICIOUSLY, LIKE A *CREATURE* OF *EVIL INTENT...*

A *VORTEX OF PANIC* CONSUMED MATT'S INNERMOST SOUL AS HE LET OUT A *SCREAM:*

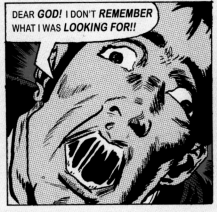

DEAR *GOD!* I DON'T *REMEMBER* WHAT I WAS *LOOKING FOR!!*

WELL, I HOPE YOU LIKED TONIGHT'S *EXPERIMENT IN TERROR,* GHOULS AND BOILS! TUNE IN NEXT TIME FOR ANOTHER *FIENDISH FORAY* INTO *FORMAL FUN* AND *STYLISH SNEAKINESS,* HAW! HAW! HAW!

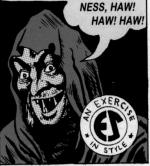

AN EXERCISE IN STYLE

Dynamic Constraint

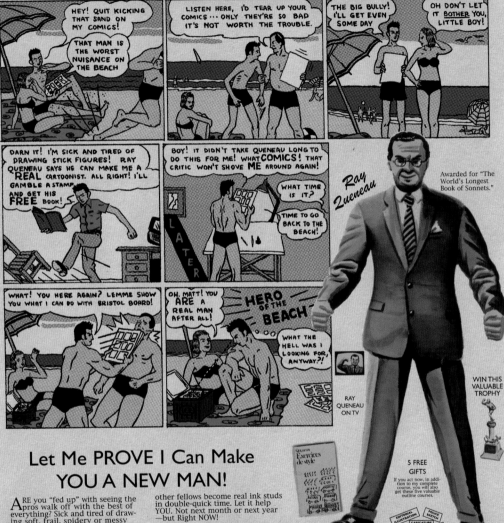

Ligne Claire

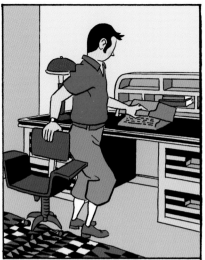
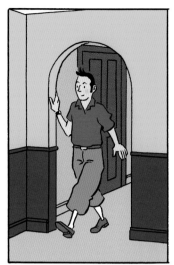
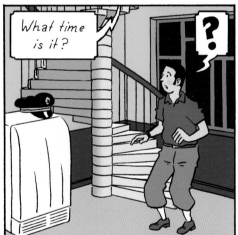
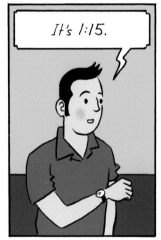
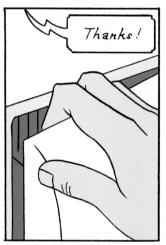
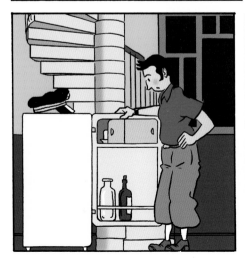
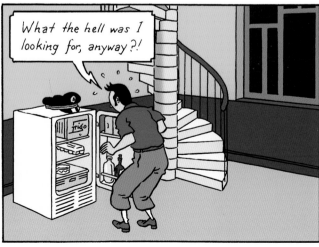

Superhero

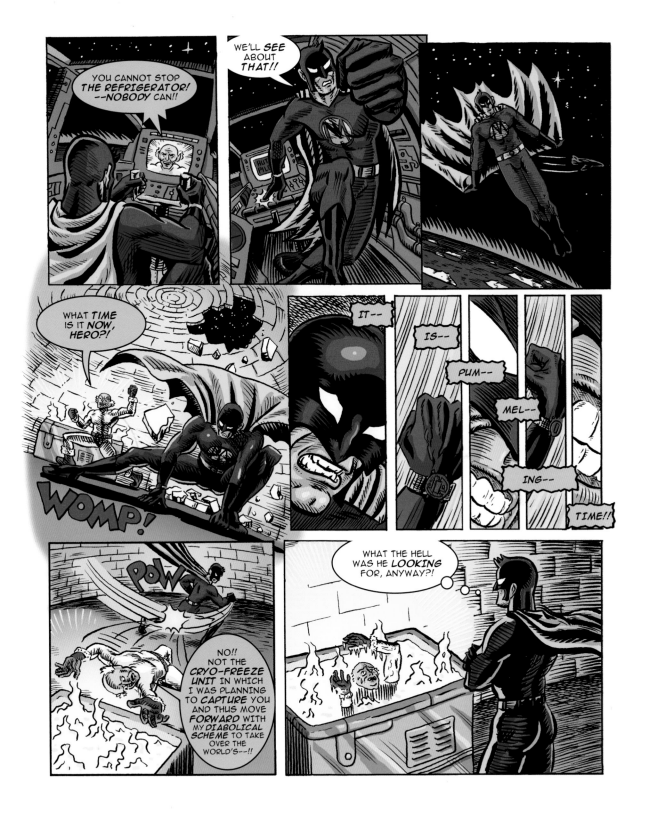

Map

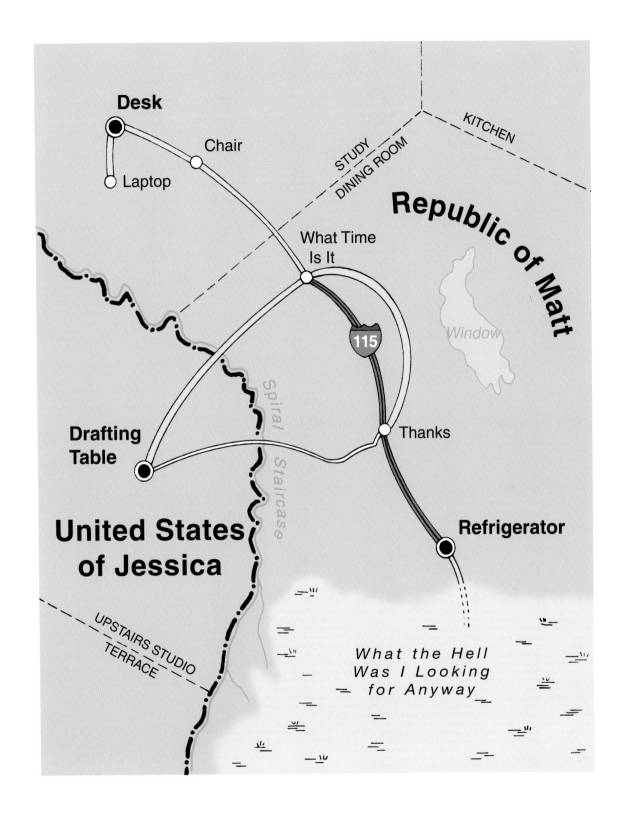

ROYGBIV

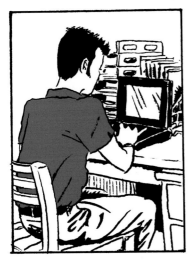

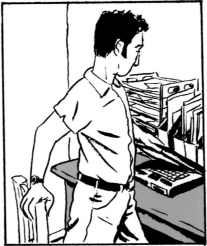

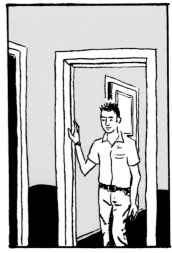

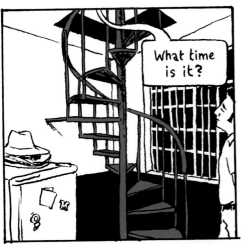

What time is it?

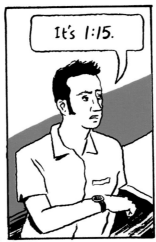

It's 1:15.

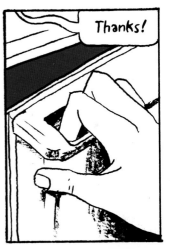

Thanks!

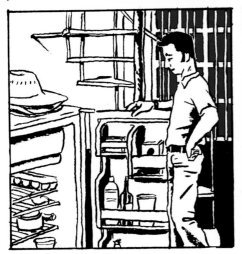

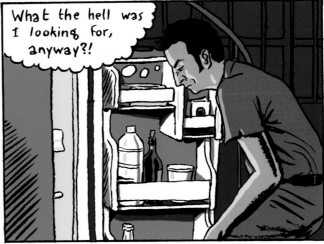

What the hell was I looking for, anyway?!

Exercises of a Rarebit Fiend
(after Winsor McCay)

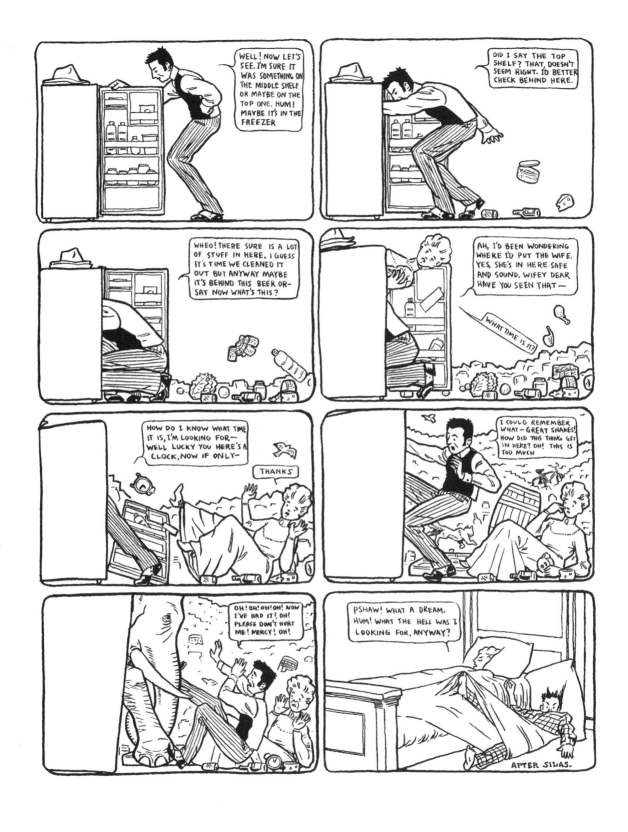

Esk Her Size end Style
(after George Herriman)

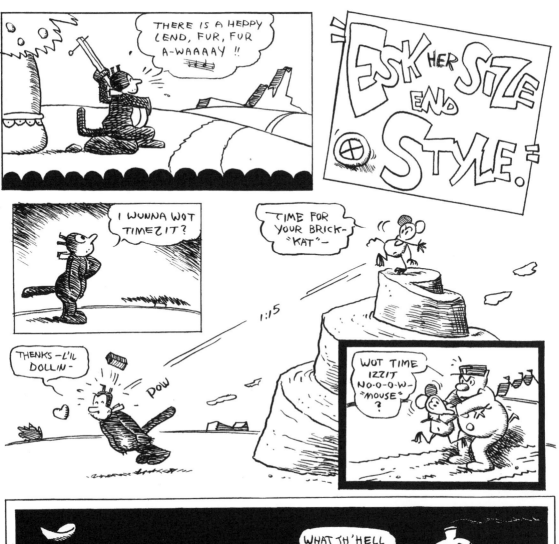

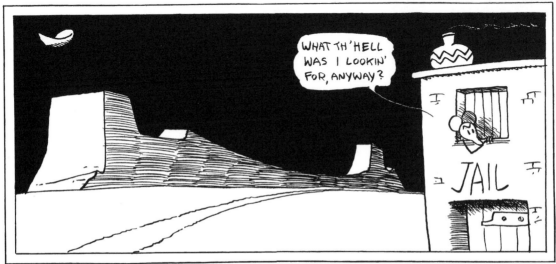

Homage to Jack Kirby

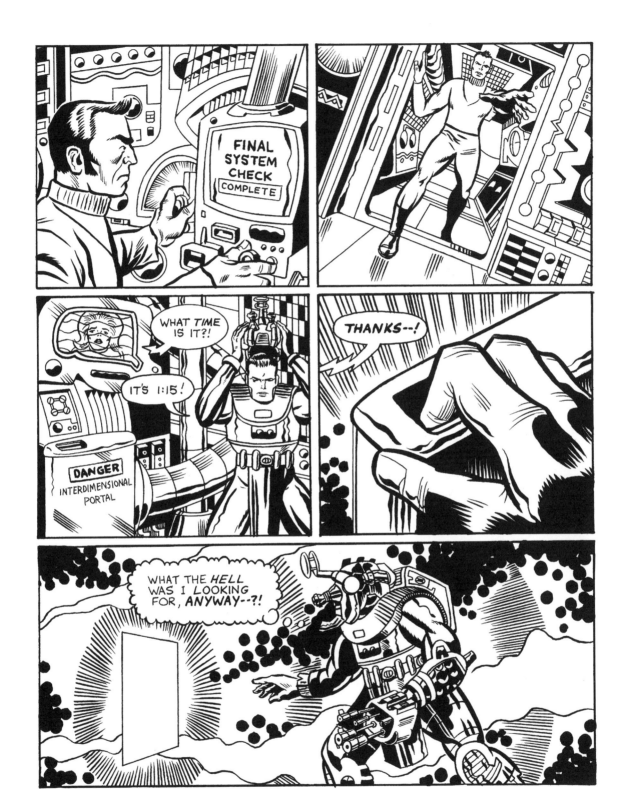

Exercises in Closure
(after Scott McCloud)

1. MOMENT-TO-MOMENT

2. ACTION-TO-ACTION

3. SUBJECT-TO-SUBJECT

4. SCENE-TO-SCENE

5. ASPECT-TO-ASPECT

6. NON-SEQUITUR

Public Service Announcement

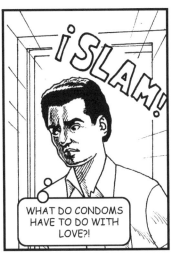

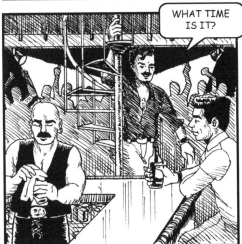

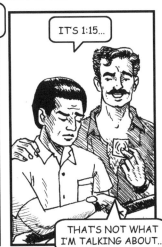

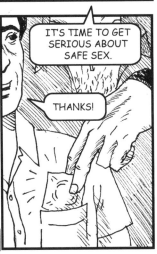

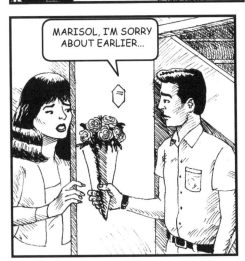

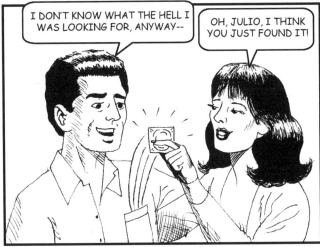

Paranoid Religious Tract

THE EXERCISE!

M.J.M

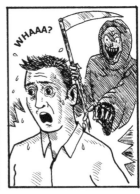

WHAAA?

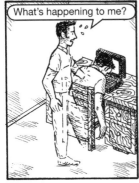

What's happening to me?

Uh-oh!

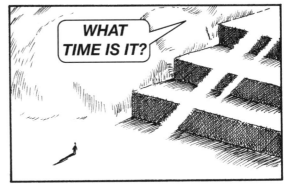

WHAT TIME IS IT?

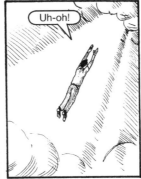

It's... time to accept Jesus Christ as my personal lord and savior!

Matt. 1:15

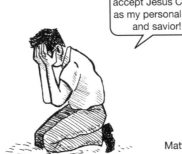

Thanks!

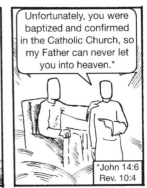

Unfortunately, you were baptized and confirmed in the Catholic Church, so my Father can never let you into heaven.*

*John 14:6
Rev. 10:4

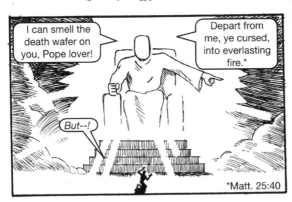

I can smell the death wafer on you, Pope lover!

Depart from me, ye cursed, into everlasting fire.*

But--!

*Matt. 25:40

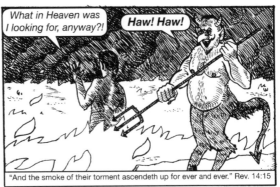

What in Heaven was I looking for, anyway?!

Haw! Haw!

"And the smoke of their torment ascendeth up for ever and ever." Rev. 14:15

Cento
(David Mazzucchelli, Ben Katchor,
Chester Brown, Marc-Antoine Mathieu,
Daniel Clowes, Art Spiegelman,
Julie Doucet, Gary Panter)

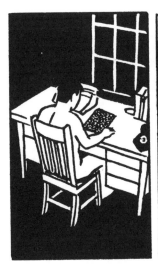

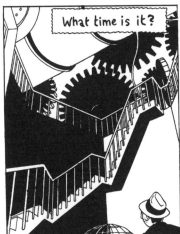
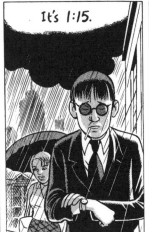

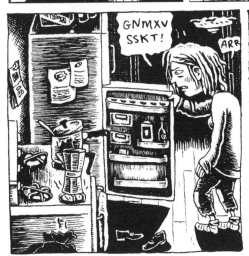
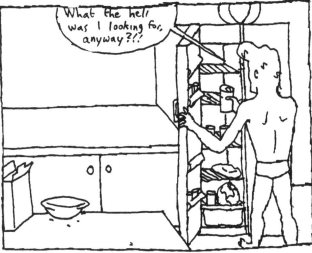

Two-in-One (Madden/Queneau)

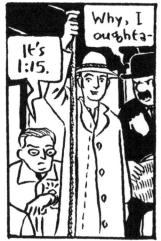

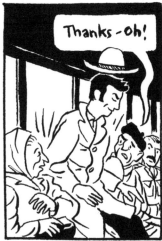

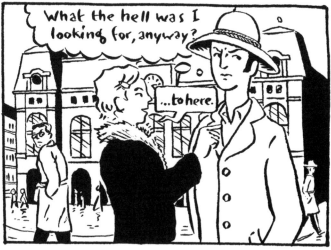

Digital

001101100001101100110101001101100111001101010101010111001101110010101110011
001010111001101110010101110011010011011001101100110101110011010101011100110
101110011011010111100110101110011010111100110011011001100101001101100111 0
01101010101010111001101110010101110011010011011001100011011001100100110001 1
01100110010101110011010111001101010101011100110101110011011010111001101011110
010101010101110011010111001101101010111001101010101011100110101111011100110101 01
011100110101110011011010010101010101100110101111001111100110111001010111 00
11001101001101100101001111100110101010101110011010110011010011011001010010 01 101
10011001101010101010101110011011110010101110011001101001101100101001101100111 1
00110101110011010101011100110101110011011010101110011010111001101010101011100
11010111001101101011001101011001101010101110011010111001101001101100101001
1011100110101111000000110111001111001101010101010111001101110010101110011 10
10101010110010101010101110011011100101011100110010100110110010100110110101111
001011001100110100110110010100111110011010101010111001101011010111001101010101
1100110101110011011010111001101011110011010111001101010101011100110101011100110
0110101110111001101010101011001101011100110110101011110011010111001101001001010010
0101011100110100110110011100110101011001101010101011001101011100110110101011100
1101011100110101010111001101011100110110101011100110101011001101010101011001101010
111001101011100110101010101110011010111001101101011100110101011110011010011011 00
10100110110011001101010111001101001101101011100110101010101110011010111001101101010
11110011010111001101001010011011001110011010101010101011100110111001010111001101
110011001101001101011001101010101010101110011011100101011100111010101111100 11
011100000111101110011011010101110011010101010111001101011101110011010101010111001
10101110011011010010101010101100110101111100111110011011100101011100110011010
011011001010011110011010101010111001101011100110100110110010010011011001110011 0
101010101010111001101110010101110011001101001101100101001101100111001101011100 1
10101010111001101010111001101101010111110011010111001101010101011001101011100110 11
010111001101011001101010101110011010111001101001011011001001001011110011010101111
00000011011100111001101010101010101110011011100101011100111010101010101110010101 0
101011100110111001010111001100110100010101110011010011011001001001011100110101 0 1
11110000001101110011110011010101010010101010101010111001101110010101110011 11010 1
0101011100101010101011100110111001010101011100110111001010111001110101010101011 1
1001010101010111001101110010101110011001101001101100101001011011100101111001 1
001101001101100101001111100110101010111001101011010111001101010101011100110101 1
1001101101011100110101111110011010111001101010101110011010111001101101011101 1
1001101010101110011010111001101101010111110011010111001101001101010010101110011 0
1001101100110011010111001101010100110101010101011100110111001010111001110101 0 1
010101110010101010101110011011100101010111001101011100110110101011110011010101 1 1
001101010101011100110101110011011010101110011010100110101010101110011010101110011 0
101110011010101011100110101110011011010111001101011110011010011011001010011 01
100111001101011100110100110110111001101010101011001101011100110110101011110011011

Graph

CHART *Representing the* EFFECT *of an* INTERRUPTION *on a* THOUGHT/ACTION *Process as It Moves Through* SPACE *and* TIME

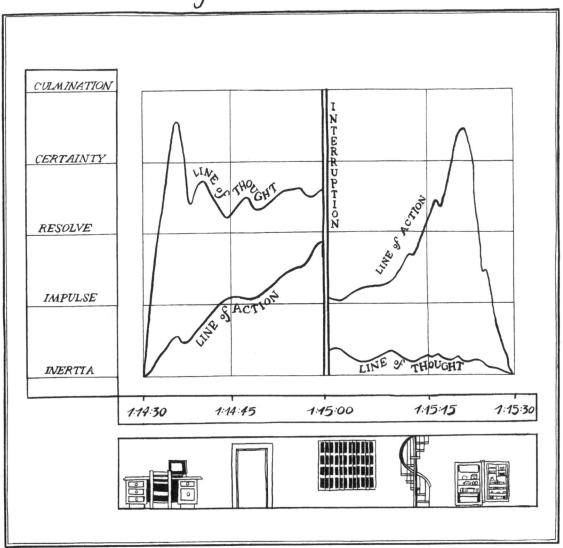

In Case of Exercises in Style

Storyboard

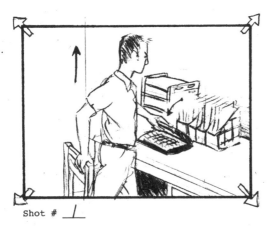

Shot # 1

DOLLY BACK slightly as MATT rises and
closes LAPTOP.

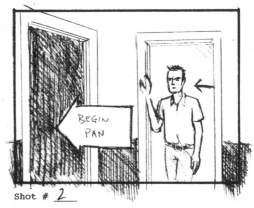

Shot # 2

MED. SHOT of MATT coming through
DOORWAY. PAN LEFT as he moves into
DINING ROOM.

Shot # 2 (cont'd)

PAN LEFT and DOLLY up STAIRCASE.

JESSICA (off)
What time is it?

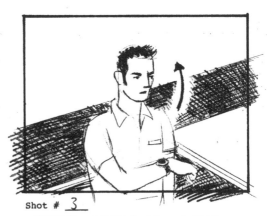

Shot # 3

CLOSE UP of MATT looking at WATCH.

MATT
It's 1:15.

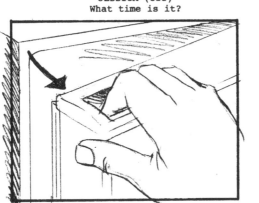

Shot # 4

**EXTREME CLOSE UP of MATT'S HAND opening
REFRIGERATOR DOOR.**

JESSICA (off)
Thanks!

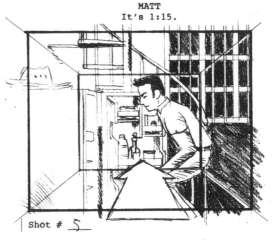

Shot # 5

Slow ZOOM/DOLLY into MATT as he
realizes he can't remember what the
hell he was looking for anyway.
FADE TO BLACK.

Brought to You by . . .

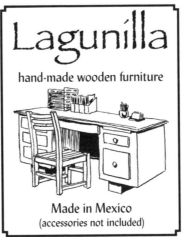
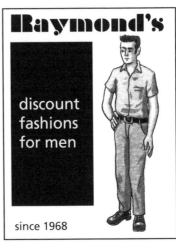

Calligram

 in
 mid-click a synapse
 fires somewhere causing me to
 abruptly put my work to sleep. You
 interrupt me en route wanting to
 know how long you have
 been procrastinating. I
 oblige happily
 after a quick
 comparison
 of big and
 small.
 However,
 when I open
 and peer
 inside the
 refrigerator
 door I find I
 can no longer
 remember
 what the
 hell I was
 looking
 for,

 any-
 way.

No Pictures
(after Kenneth Koch)

(IT'S)

A MAN ,

A PLAN :

(A CANAL?)

NO, OF COURSE NOT!

IT'S—

"What time is it?"

(huh?)

TICK

IT'S 1:15.

TOCK

"Thanks."

IT'S NO HAY DE NICHTS.

IT'S

TICK
TOCK
TICK
TOCK
TICK
TOCK

IT'S IT'S

IT'S

WHAT THE HELL WAS I LOOKING FOR, ANYWAY?!

Personification

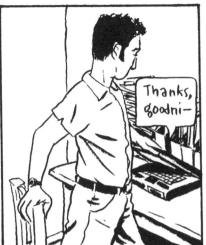

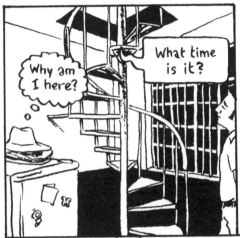

The Next Day

It's funny, last night while you were upstairs...

At a certain point I got up and, uh...

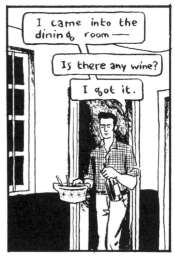

I came into the dining room—

Is there any wine?

I got it.

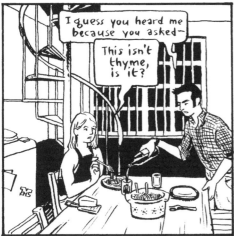

I guess you heard me because you asked—

This isn't thyme, is it?

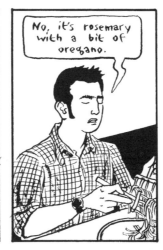

No, it's rosemary with a bit of oregano.

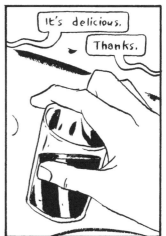

It's delicious.

Thanks.

What the hell was I just talking about, anyway?!

Nested Stories

There once was a young girl who danced with the M___ Follies in R____.

"One night she got up suddenly from her dressing table and declared:"

I must write to father...

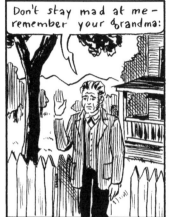

"He was so upset the day I left!"

Don't stay mad at me— remember your grandma:

"She refused to be in the same room with my father for fifteen years."

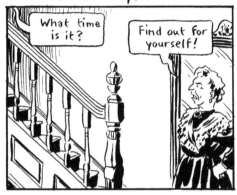

What time is it?

Find out for yourself!

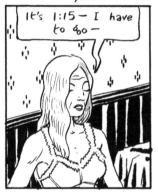

"Or maybe you'd like to ask that floozy, Janet!"

It's 1:15 — I have to go —

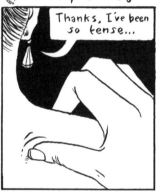

"I've got to give Mrs. Monceau her weekly massage."

Thanks, I've been so tense...

"It's my husband: he won't stop talking about our dead son!"

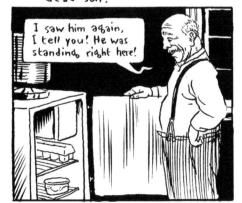

I saw him again, I tell you! He was standing right here!

"It's as if his soul can't rest, like he's looking for something and he can't remember what the hell it is!"

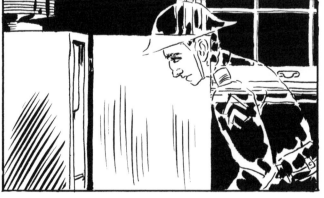

Overheard in a Bar

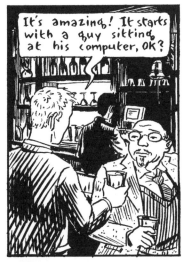

It's amazing! It starts with a guy sitting at his computer, OK?

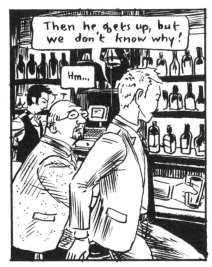

Then he gets up, but we don't know why!

Hm...,

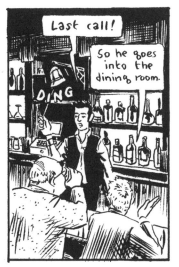

Last call!

So he goes into the dining room.

DING

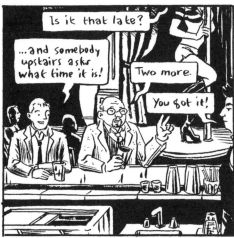

Is it that late?

...and somebody upstairs asks what time it is!

Two more.

You got it!

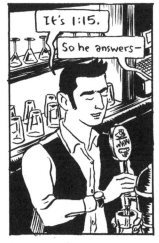

It's 1:15.

So he answers—

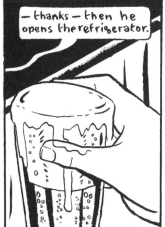

—thanks—then he opens the refrigerator.

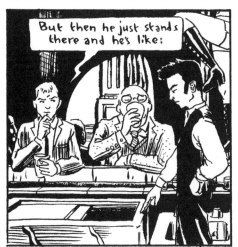

But then he just stands there and he's like:

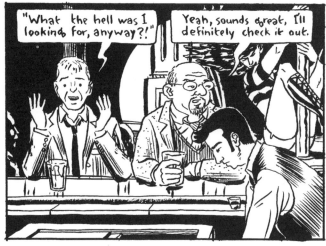

"What the hell was I looking for, anyway?!"

Yeah, sounds great, I'll definitely check it out.

Happy Couple

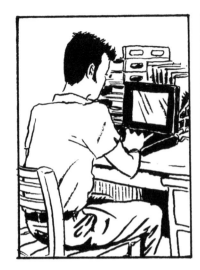
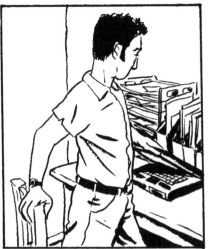
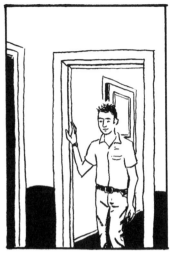
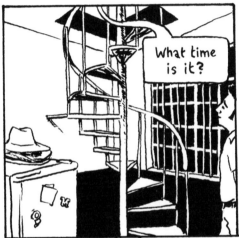
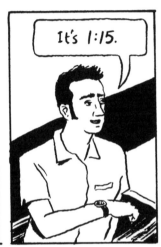

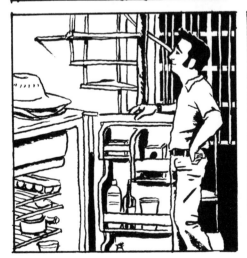
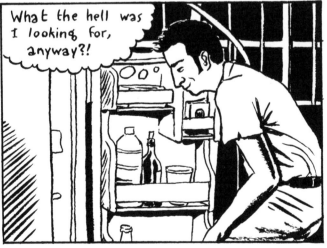

Unhappy Couple

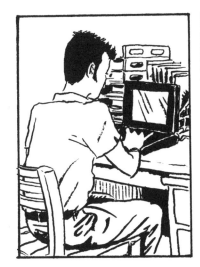
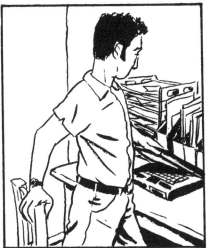
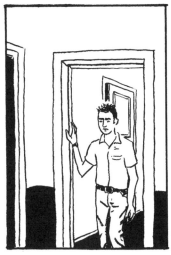
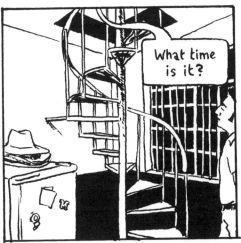

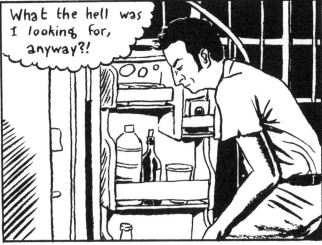

A Life

What time is it?

It's 1:15.

Thanks!

What the hell was I looking for, anyway?!

Around the World

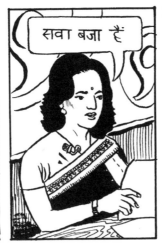
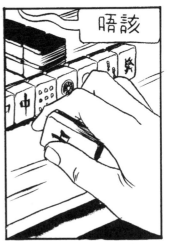

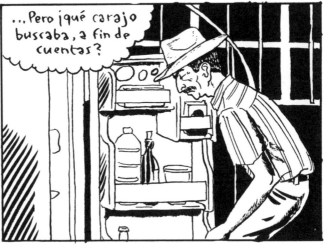

The Critic

The first panel of this comic presents the protagonist with his back to us in the act of typing — possibly he is writing

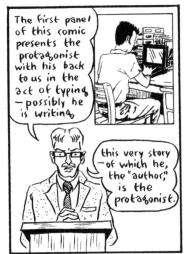

this very story — of which he, the "author," is the protagonist.

The protagonist rises, contorting himself as if to delay showing his face for one more panel. This act of avoidance forces the reader to interrogate

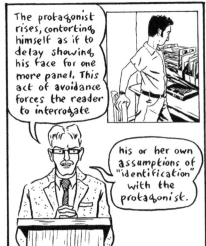

his or her own assumptions of "identification" with the protagonist.

Here, the protagonist finally, if reluctantly, faces the reader, framed by a doorway, a kind of inset panel:

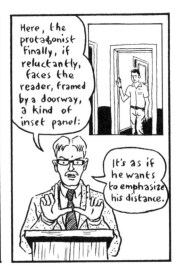

It's as if he wants to emphasize his distance.

Here the protagonist seems to retreat out of the panel as he is simultaneously confronted by an off-panel voice — does it represent the reader?

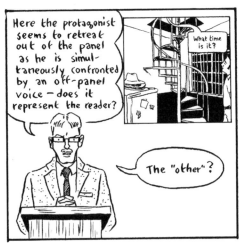

What time is it?

The "other"?

The terse exchange on the subject of time seems to suggest that human communication

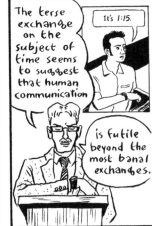

It's 1:15.

is futile beyond the most banal exchanges.

This abrupt shift to a subjective shot of a hand opening a refrigerator door forces the reader to

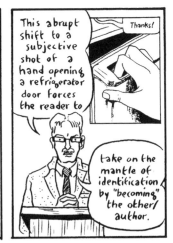

Thanks!

take on the mantle of identification by "becoming" the other/author.

By switching to a long shot, the author again re-asserts the protagonist's otherness.

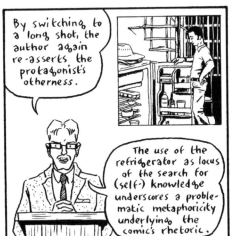

The use of the refrigerator as locus of the search for (self-) knowledge underscores a problematic metaphoricity underlying the comic's rhetoric.

The last panel seems to suggest that the protagonist's (and perhaps the author's) quest for knowledge has been in vain. Indeed, the aggressively defensive stance and glassy, uncomprehending gaze of the protagonist/author seems to defiantly

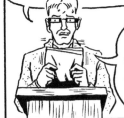

What the hell was I looking for, anyway?!

head off the reader, barring his/her exit from the comic. The critic is easily able to dodge such facile obstructions, yet he finds himself wondering, in the end what the hell he was looking for, anyway.

Evolution

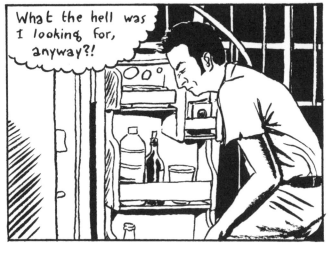

Creationism

And God said, let there be light, and there was light.

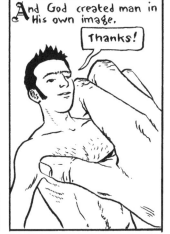

And God said, let there be a firmament, and it was so.

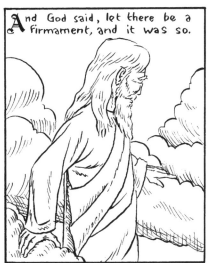

And God created the Earth and the seas and saw that it was good.

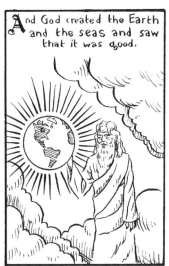

And God said let there be lights to divide the days, hours, and minutes, that the time might be known.

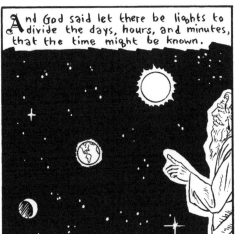

And God filled the waters and the earth with creatures, and it was 1:15 on the fifth day.

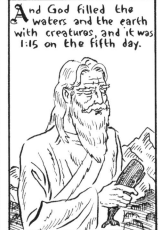

And God created man in His own image.

Thanks!

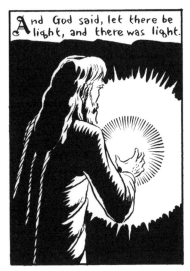

And on the seventh day He rested from all His work which He had made.

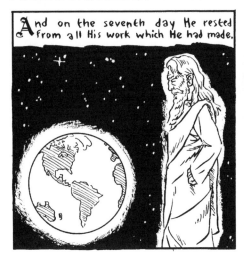

Yet on the eighth day, He did wonder what the hell He was looking for, anyway...

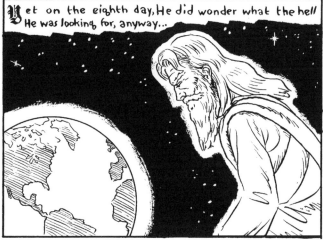

A Lifetime to Get to the Refrigerator

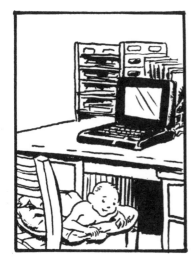

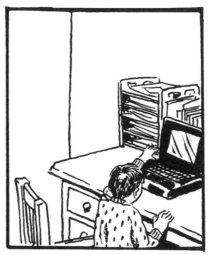

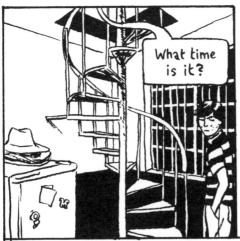

What time is it?

It's 1:15.

Thanks!

What the hell was I looking for, anyway?!

Actor's Studio I

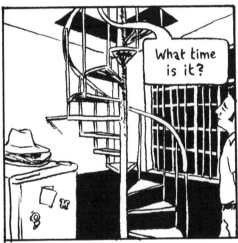

What time is it?

It's 1:15.

Thanks!

Umm...

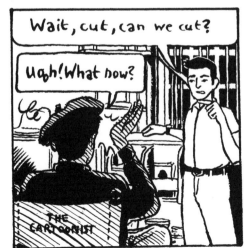

Wait, cut, can we cut?

Ugh! What now?

THE CARTOONIST

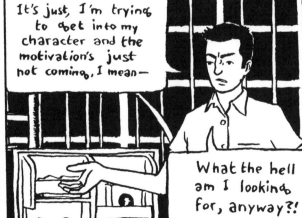

It's just, I'm trying to get into my character and the motivation's just not coming, I mean—

What the hell am I looking for, anyway?!

Actor's Studio II

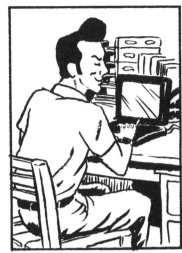
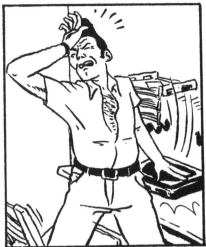
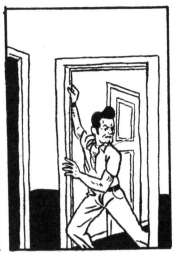
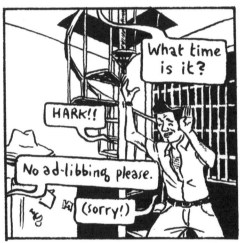

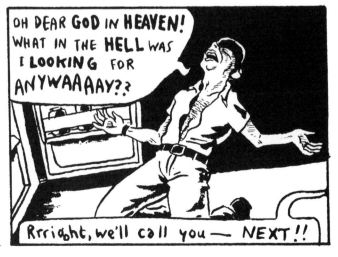

Horizontal

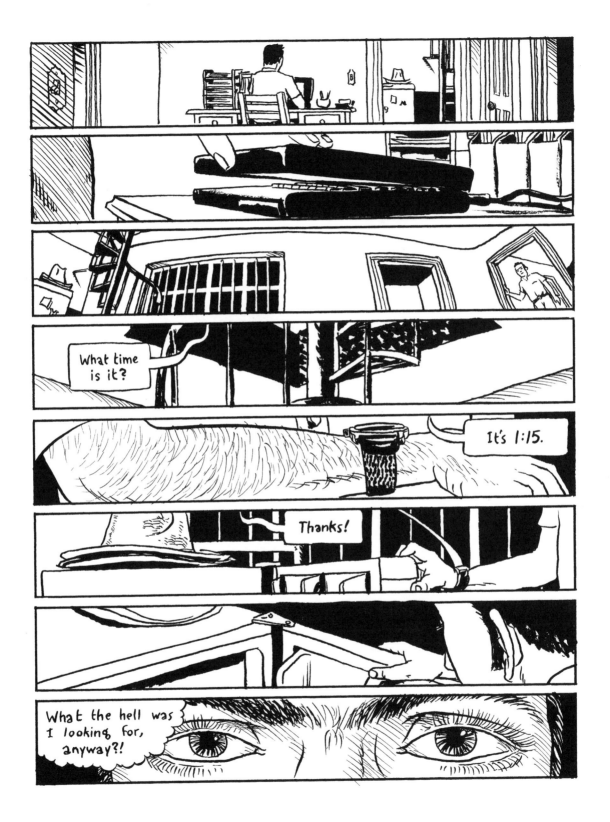

Vertical

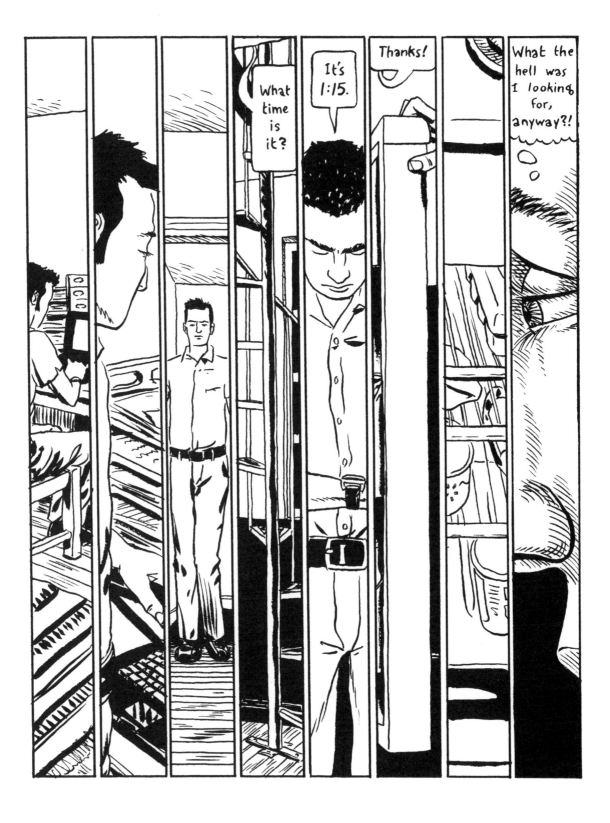

Extreme Close-Ups

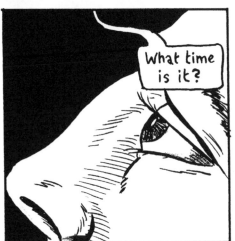
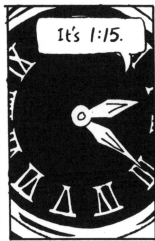

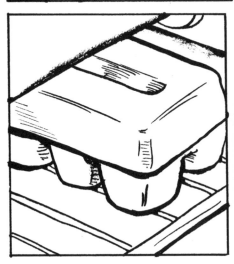

Long Shots

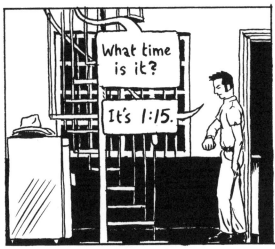

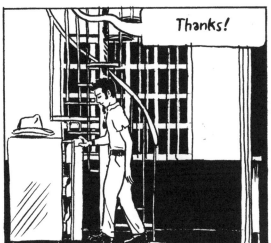

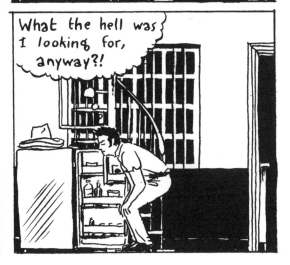

Extreme Zoom

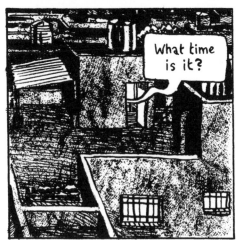

What time is it?

It's 1:15.

Thanks!

What the hell was I looking for, anyway?!

Things Are Queer
(after Duane Michals)

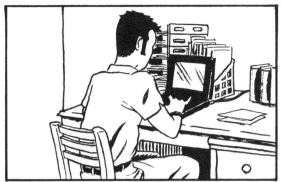

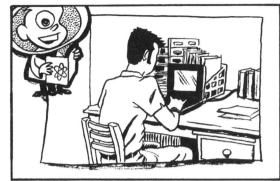

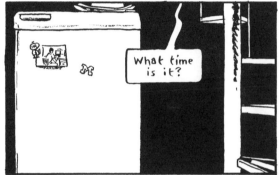

Isometric Projection

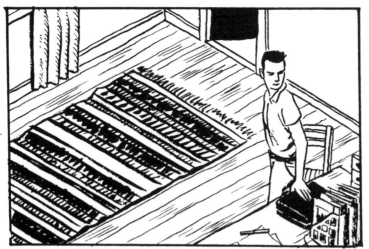
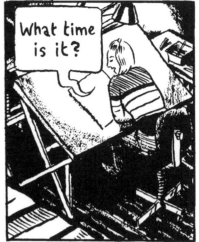
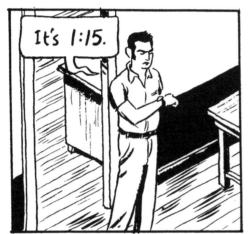

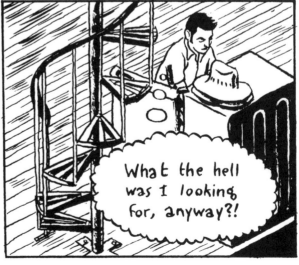

Our House

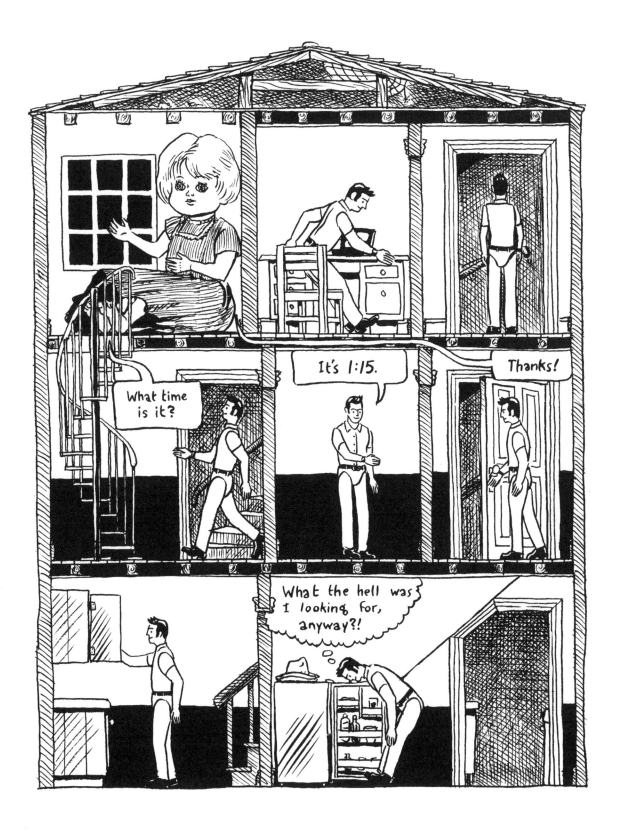

One Horizon

What time is it?

It's 1:15.

Thanks!

What the hell was I looking for, anyway?!

Too Much Text

Panel 1: Matt Madden was working at his computer late one evening in Mexico City, Mexico.

Panel 2: Suddenly a notion occurred to him, one of those vague impulses one acts on before it has even fully formed.

He put his computer to sleep and got up out of his chair.

Panel 3: He walked into the dining room, where, for lack of space in the kitchen, they kept the refrigerator.

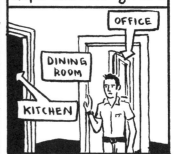

OFFICE

DINING ROOM

KITCHEN

Panel 4: Matt's girlfriend Jessica called down from upstairs at that instant to ask what time it was.

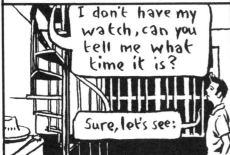

I don't have my watch, can you tell me what time it is?

Sure, let's see:

Panel 5: Matt looked at the big hand and then at the little hand and then declared that it was 1:15 AM.

It's 1:15 in the morning.

Panel 6: Jessica said thanks from upstairs in the studio, where she was working on her next comic.

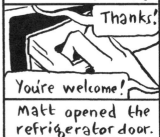

Thanks!

You're welcome!

Matt opened the refrigerator door.

Panel 7: At this moment something odd happened or rather revealed itself to have already happened: Matt stood at the refrigerator, studying its contents and trying to recall why he was standing there.

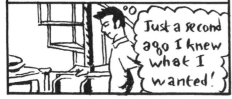

Just a second ago I knew what I wanted!

Panel 8: Matt leaned forward, his hands clasping his knees, and furrowed his brow, perplexed, as he tried in vain to recall what he had come looking for. Yet he found that no matter how he tried he could no longer remember what the hell he was looking for.

What the hell was I looking for anyway?

It didn't make sense: how could he have forgotten something he had clear in his mind just seconds earlier? Still, however much he racked his brains trying to recall the forgotten item (was it even in the refrigerator?? Maybe it was upstairs in the studio?) he

No Line

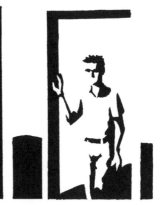

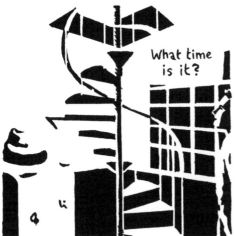
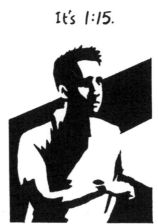
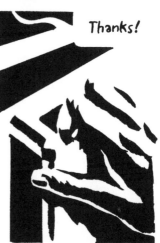

It's 1:15.

Thanks!

What time is it?

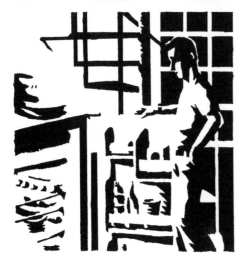

What the hell was I looking for, anyway?!

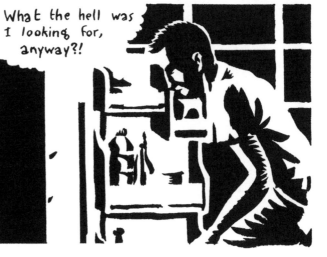

Silhouette

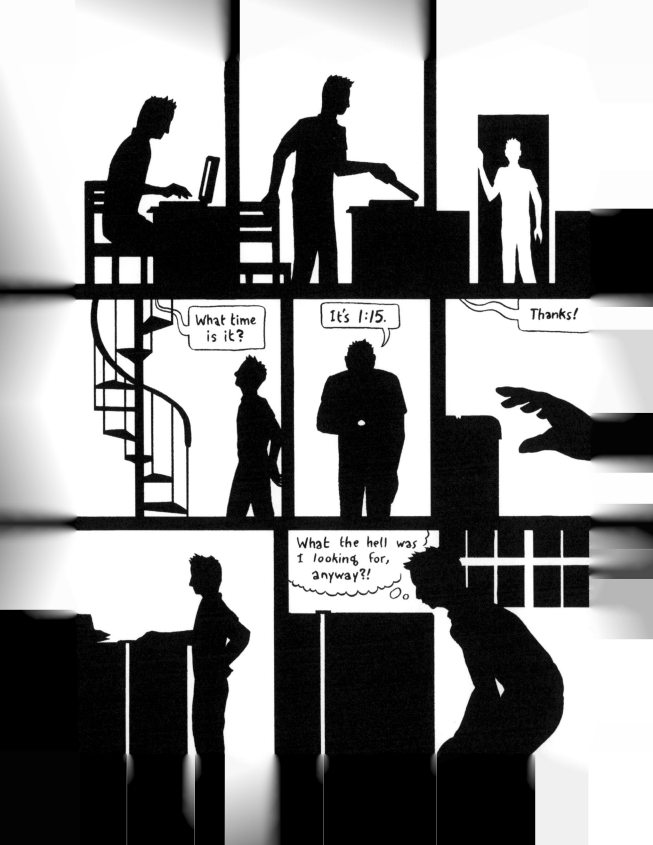

Minimalist

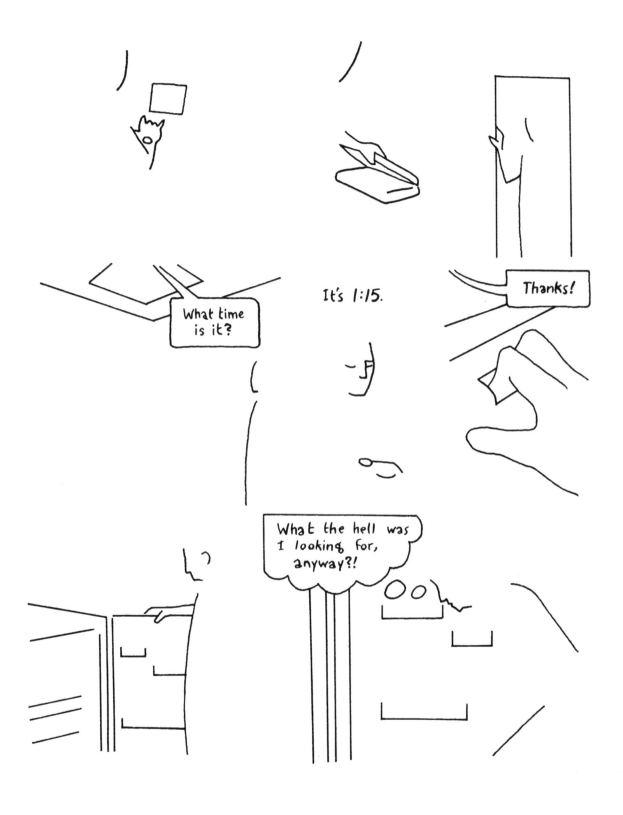

Maximalist

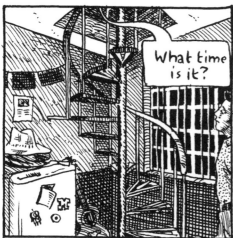

What time is it?

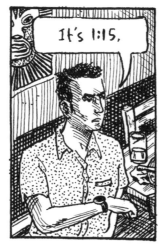

It's 1:15,

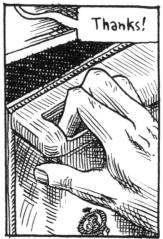

Thanks!

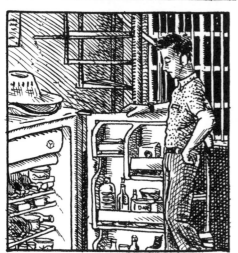

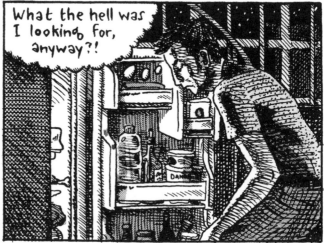

What the hell was I looking for, anyway?!

Fixed Point in Space

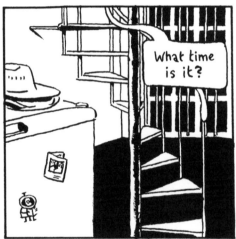
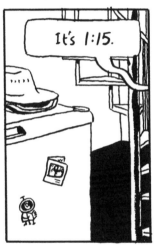
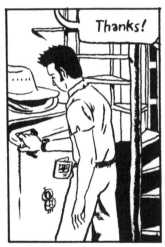
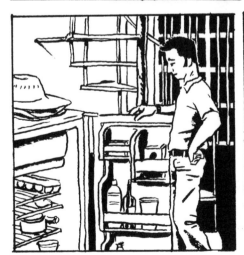

Fixed Point in Time

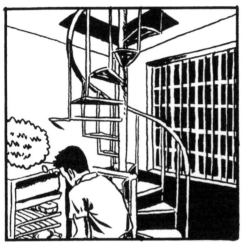

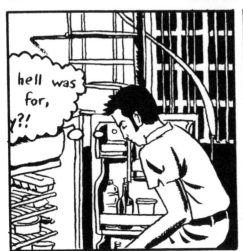

What's Wrong with This Comic?
(Two Changes in Every Panel)

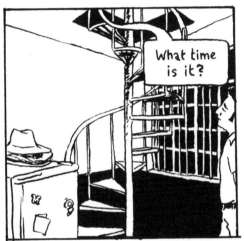
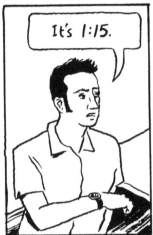
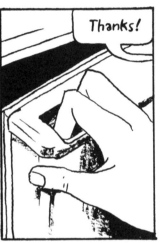
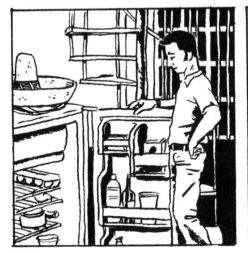

Different Text

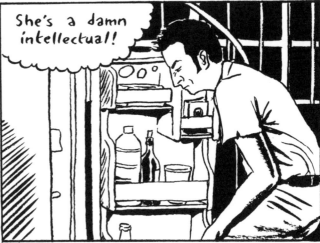

Different Images

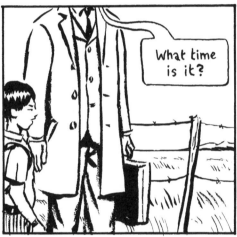
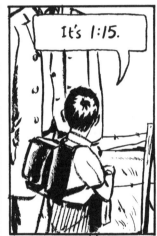
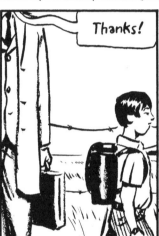

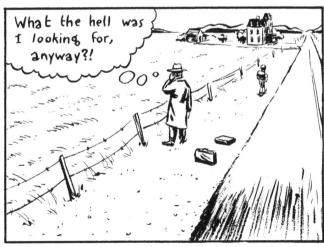

No Refrigerator

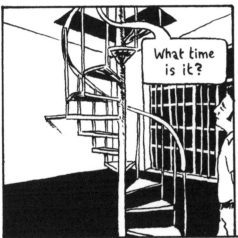
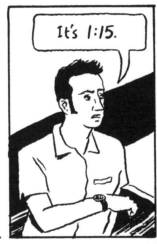
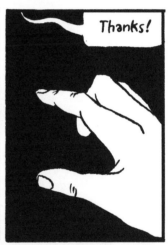
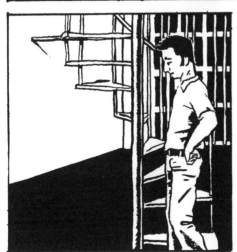

No Jessica

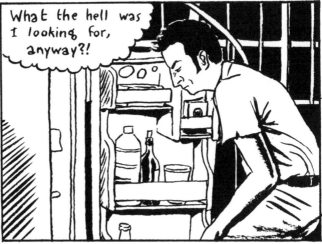

What the hell was I looking for, anyway?!

No Matt

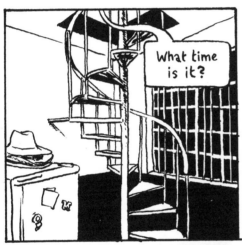

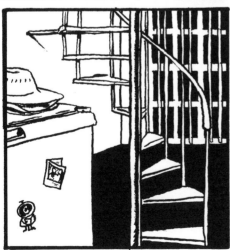

Notes on Some
of the Exercises

Emanata (p. 17):

This neologism is used by many cartoonists to describe the motion lines, flying sweat beads, and stars that are so characteristic of comics. The word was coined by cartoonist Mort Walker (b. 1923) in his *Lexicon of Comicana*, a tongue-in-cheek taxonomy which gives individual names to all sorts of marks and squiggles that have specific meaning in comics. "emanata" is actually intended as just one of these words—denoting squiggly lines that emanate from the head and end with musical notes (for whistling), hearts (for people in love) and so on—but it has been adopted by many cartoonists as the generic term, instead of Walker's own "comicana."

Photocomic (p. 39):

The photocomic (also referred to as a *fumetto* or *fotonovela*) has never had a large presence in the United States, but in Europe and Latin America it has a long history as a source of pulpy, murkily printed soap operas and masked wrestler adventures.

Manga (p. 43):

Manga is Japanese for "comic." Note that, being a Japanese version, this comic reads from right to left! The translation and sound effects were done by my friend Tomofusa Sato. Here's how to read the sound effects: Panel 1: Kacha Kacha; Panel 2: Patan; Panel 3: Zap; Panel 6: Kata; Panel 8: Boooon.

Furry (p. 59):

Anthropomorphism has a long and rich history in comics, from Mickey to Maus. This comic has a little fun with the subgenre/subculture known as "furries." (Look in any internet search engine for more information than you could possibly care to have.)

Anagrams (p. 77, 79):

An anagram is a word or phrase whose letters are rearranged to form a new phrase or word. "Anagram I" rearranges the panels and the words within their corresponding balloons, while "Anagram II" rearranges every individual element of the comic: letters, panel borders, objects, and so on.

Rodolphe Töppfer (p. 81):

Rodolphe Töppfer (1799–1846) was a Swiss educator and cartoonist considered by many to be the founder of the modern comic, based on a series of satirical pamphlets he published in the 1830s including *Histoire de M. Jabot* (1833) and *Les Amours de M. Vieuxbois* (1839). The latter book was published in an unauthorized English edition (as were many of his books) known as *The Adventures of Mr. Obadiah Oldbuck*.

A Newly Discovered Fragment of the Bayeux Tapestry (p. 83):

The Bayeux Tapestry was made in the eleventh century to comemmorate the Battle of Hastings (1066). It is often cited as a precursor to comics because of its "strip" form, its linear narrative continuity, and its combination of text and image.

What Happens When the Ice Truck Comes to Hogan's Alley (p. 85):

"Hogan's Alley" was a newspaper cartoon created by Richard F. Outcault (1863–1928). It introduced one of the icons of the comics medium, the Yellow Kid, and was at the center of the infamous newspaper power struggles between William Randolph Hearst and Joseph Pulitzer at the turn of the twentieth century.

Exorcise in Style (p. 87):

This comic is a tribute to *Tales from the Crypt*, and more generally to the influential batch of lurid horror, science fiction, and other genre comics published by EC comics in the 1950s.

Dynamic Constraint (p. 89):

Surely one of the most famous print advertising campaigns of all time, comics promoting the Charles Atlas bodybuilding course were a common feature of comics and magazines throughout the latter half of the twentieth century.

Ligne Claire (p. 91):

Ligne claire or "clear line" is a term introduced by European comics critics in the 1970s to describe comics that emphasized a clean graphic style, clear storytelling, and flat colors. The originator of the style remains its best: the Belgian Georges Remi, aka Hergé (1907–1983), creator of *The Adventures of Tintin*.

Exercises of a Rarebit Fiend (p. 99):

Winsor McCay (1869–1934) was an early cartoonist and animator, and the creator of "Little Nemo in Slumberland", "Gertie the Dinosaur," and "Dreams of a Rarebit Fiend," which inspired this strip.

Esk Her Size end Style (p. 101):

George Herriman (1880–1944) was the creator of *Krazy Kat*, widely acknowledged as one of the all-time high-water marks in comics, even though it was hardly read in its time.

Homage to Jack Kirby (p. 103):

Jack "King" Kirby (1917–1994) is considered one of the all-time great comic book artists. He is perhaps best known as the co-creator of such superheroes as the Fantastic Four and Captain America.

Exercises in Closure (p. 105):

This comic is a tribute to Scott McCloud's epochal *Understanding Comics* (Perennial Currents) and its most important contribution to the discussion of comics: the concept of "closure," referring to the connection the mind makes between two panels, allowing the creation of narrative meaning.

Cento (p. 111):

A *cento* (pronounced "sento," from the Latin for "patchwork") is a poem made up entirely of lines quoted from another poet.

Two in One (p.113):

This comic fuses my story with the one Raymond Queneau used for the original prose *Exercises in Style* (available in English from New Directions).

Calligram (p.125):

A calligram is a poem where the body of the text is laid out in such a way as to create a silhouette-like image.

No Pictures (p.127):

This comic was inspired by the "comics mainly without pictures," of poet Kenneth Koch (1925–2002), which fuse the languages of poetry and comics in novel ways. They were collected in a book called *The Art of the Possible* (Soft Skull Press).

Around the World (p.143):

The specific path this comic follows moves due east along roughly the 15th parallel north of the equator. The places visited are: Cuba, Cape Verde, Mali, Saudi Arabia, India, China (Hong Kong), Hawaii, and Mexico.

Things Are Queer (p.167):

This comic, a kind of perpetual zoom loop, was inspired by a series of photographs (from which I also borrowed the title) by Duane Michals (b. 1932), who has created many comics-like, multi-photo narrative sequences in his work.

Isometric Projection (p.169):

In an isometric projection all three faces are equally inclined to the drawing surface and parallel lines do not converge on a horizontal line.

What's Wrong with This Comic? (p.189):

Panel 1: chair missing back slat; extra paper tray
Panel 2: no sideburn; no watch
Panel 3: no belt; watch on opposite hand
Panel 4: staircase flipped, magnets re-arranged
Panel 5: shirt pocket gone; no painted wainscoting
Panel 6: no ring finger; tail of word balloon moved
Panel 7: giant sombrero; no support bar on staircase
Panel 8: no wine bottle; no bannister

Different Text (p.191):

The text I substituted here is a paraphrase of a wonderful one page strip from the book *Jack Survives* by Jerry Moriarity (b. 1938) (Raw Books and Graphics).

Acknowledgments

Thanks:

Nicholas Breutzman, Desmond Brice, Chester Brown, Daniel Clowes,
Shanna Compton, Marina Corral, Julie Doucet, Max Fenton, Stephen Frug,
Giancarlo Goria, Thierry Groensteen, Gene Kannenberg, Jr., Ben Katchor,
Yasmeen Khan, David Lasky, Jason Little, Jeff Mason, Marc-Antoine Mathieu,
David Mazzucchelli, Scott McCloud, Tom Motley, Gary Panter, Thomas Ragon,
Tomofusa Sato, Art Spiegelman, Gregory Trowbridge, Chris Waldron

Special Thanks:

Dominick Abel, Jessica Abel, Sally and Don Madden,
Andrew and Peter Madden, Bob Mecoy, Charles Orr

About the Author

Matt Madden started self-publishing minicomics in the early 1990s. He produced his first graphic novel, *Black Candy* (Black Eye Books) in 1998, and in 2001 published *Odds Off* (Highwater Books). Madden lives in Brooklyn with his wife, the author and cartoonist Jessica Abel. He works in comics and illustration, and teaches at both the School of Visual Arts and Yale University. His latest works appear in *A Fine Mess*, his bi-annual series published by Alternative Comics. You can learn more about him at www.mattmadden.com or www.exercisesinstyle.com.